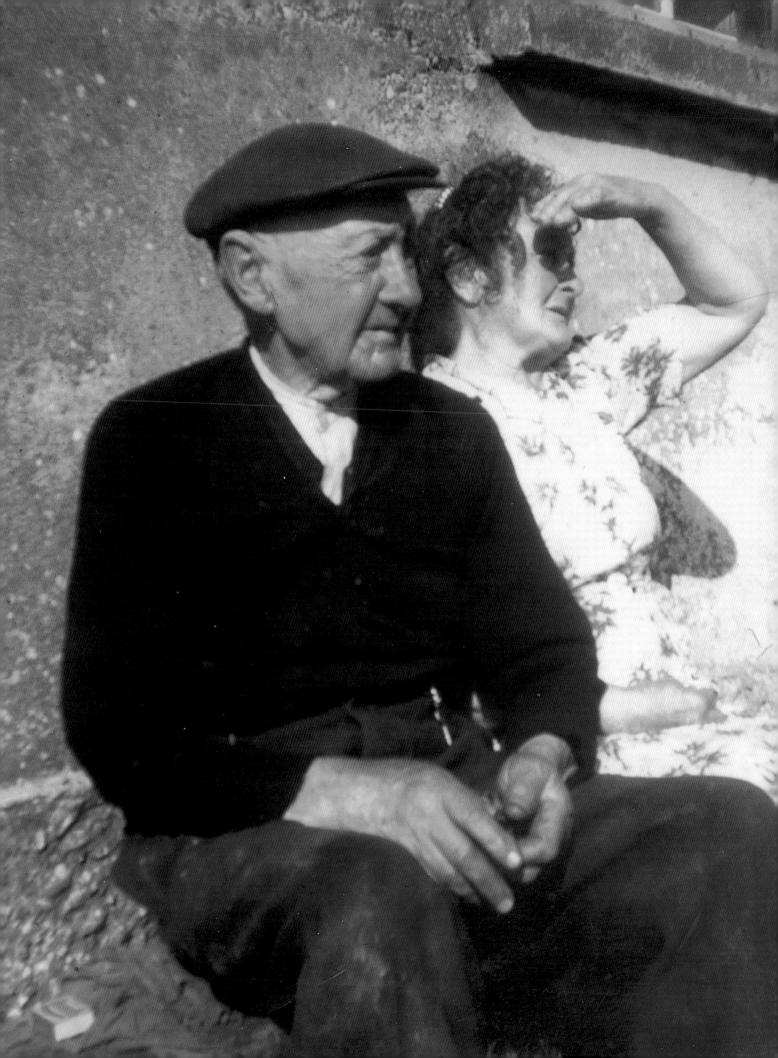

TWO PAINTERS
Works by Alfred Wallis and James Dixon

MERRELL HOLBERTON

PUBLISHERS LONDON

in association with
Irish Museum of Modern Art
and
Tate Gallery St Ives

Published on the occasion of the exhibition
Two Painters: Works by Alfred Wallis and James Dixon
at the Irish Museum of Modern Art, 1 September – 21 November 1999
and the Tate Gallery St Ives, May – November 2000

The Irish Museum of Modern Art is grateful to those who have generously lent their works to the exhibition.
In particular we should like to thank Dr Derek Hill, Chris Wilson at the Glebe Gallery, Kettle's Yard, Charu Vallabhbhai,
Chris Bailey, William Gallagher, Robin Light and the Crane Kalman Gallery, Ronan McCrea, Peter Barnes, Veronica
Tierney, The Tate Gallery Archive and Library, Matthew Gale, the Ulster Museum and Duchas – The Heritage Service.

Exhibition supported by:

Text ©1999 Irish Museum of Modern Art, Tate Gallery St Ives and the authors
Illustrations © the copyright holders; for details see p. 127

First published in 1999 by
Merrell Holberton Publishers Limited
42 Southwark Street, London SE1 1UN
in association with
Irish Museum of Modern Art
Royal Hospital, Military Road,
Kilmainham, Dublin 8
and
Tate Gallery St Ives
Porthmeor Beach, St Ives TR26 1TG

Distributed in the USA and Canada by Rizzoli International Publications, Inc.
through St Martin's Press, 175 Fifth Avenue, New York, NY 10010

British Library Cataloguing in Publication Data
Gale, Matthew
Two painters : works by Alfred Wallis and James Dixon
1.Wallis, Alfred, 1855–1942 2.Dixon, James 3.Outsider art
4.Painting, English 5.Painting, Irish 6.Painting, Modern
– 20th century – England 7.Painting, Modern – 20th century –
Ireland
I.Title II.Ingleby, Richard, 1967– III.Irish Museum of Modern Art
759.2

ISBN 1 85894 085 0

Compiled by Sarah Glennie
Designed by Karen Wilks

Produced by Merrell Holberton Publishers Limited
Printed and bound in Italy

Frontispiece (p. 1): Alfred Wallis at 3 Back Road West, St Ives, *ca.* 1928. *Tate Gallery Archive*
Frontispiece (p. 2): James Dixon and his sister Grace outside the artist's workshop at West End, Tory Island, 1964. *Photograph by W.M.Patterson*

Contents

Foreword

Alfred Wallis and James Dixon are two artists from different generations and from different places – one from England and the other from Ireland. Wallis was from St Ives, Cornwall, while Dixon was from Tory Island, off the north coast of Co. Donegal. There are similarities, however, between their approaches to painting, their backgrounds, and their positions within the art world that make a consecutive exhibition in Dublin and St Ives both relevant and timely.

This is the first exhibition of the work of Alfred Wallis in Ireland and the first ever substantial museum exhibition of the work of James Dixon. Alfred Wallis's work has been widely seen in St Ives and is now central to the Tate Gallery St Ives's displays, but this will be the first time that a substantial body of James Dixon's paintings have been seen in England since the exhibition at the Portal Gallery, London, in 1968.

Both Wallis and Dixon were fishermen by trade who took up painting late in life and managed to become significant figures in the history of twentieth-century art. Their works are represented in many major collections and both artists have had their work exhibited internationally. Neither received any official art training, which has led to them being bracketed as 'primitive' or 'naïve'. Both had close relationships with professional artists, who introduced their work into the art world of the time and secured their place in art history; Wallis with Ben Nicholson and Christopher Wood and Dixon with the British painter Derek Hill.

The prevailing approach to the work of 'primitive' artists, emphasizing their pure, childlike expression, downplays the intentions and decisions of the artists. This reading inevitably leads to a limited discussion of the works which does not extend to the complex compositions, range of subject-matter and treatment of paint seen in the work of both artists. This book aims to illustrate the depth and variety of the paintings of Alfred Wallis and James Dixon and so provide a platform for new, expanded interpretations.

As the emphasis in art turned away from imitation towards expression during the twentieth century, the work of untrained or 'primitive' artists became an important influence for Modernist painters and was actively sought out. Artists looked for a directness and purity of expression in the work of untrained artists and celebrated the apparent lack of decision-making or analysis in the work. For example, Picasso and Braque looked to the work of Henri 'le Douanier' Rousseau in France at the beginning of the century, and later Dubuffet actively collected 'L'Art Brut' or 'Outsider' art. Ben Nicholson once remarked of Alfred Wallis, "One finds the influences one is looking for".

In his essay for this book, Matthew Gale looks at this search for the 'authentic' within Modernism and places Wallis and Dixon within this narrative. He also studies the relationship that emerged between professional artists and the 'naïve discovered' artists and how these relationships have formed a filter through which this work has been experienced and discussed.

Alfred Wallis and James Dixon both lived in remote, rugged coastal locations, and this has affected interpretations of their paintings. Ben Nicholson and Christopher Wood, who 'discovered' Wallis in the 1930s, were both in Cornwall because of its romantic, 'unspoilt' connotations, and their interest in Wallis was intensified by his intrinsic relationship to that environment. Tory Island equally represented a romantic retreat for Derek Hill, the British artist who 'discovered' Dixon. In his text, Richard Ingleby looks at this desire to be by the sea and its romanticism throughout twentieth-century British and Irish art.

As with many artists who have had intriguing, unusual life stories, mythologies have built up about Wallis and Dixon that prioritize certain aspects of their work at the expense of others. Their closeness to the sea, both physically and emotionally, has led to both artists being seen as painters of boats above all else. While the sea is clearly a source of inspiration to Wallis and Dixon, they painted many other subjects, including inland scenes, religious imagery and portraits. Their encounters with professional artists have frequently been seen as providing a creative impetus for the artists. For example, it can be read that Dixon's comment on meeting Derek Hill, "I could do that", was the catalyst for his painting, but he was in fact painting before this meeting between 1956 and 1958, giving paintings to Wallace Clark, a regular visitor to Tory Island, during the early 1950s. This knowledge turns his claim into a confident challenge rather than a flippant remark on stumbling across a painter. Also, his decision to use donkey-hair brushes can be seen to derive from experience, not eccentricity.

Such myths have grown largely because there has been a limited number of sources, and in this book we therefore reproduce key texts on both the artists – texts that show how aspects of the original stories have grown in their retelling. Their inclusion also provides an opportunity to study these crucial texts together, many of which are now difficult to find. Alfred Wallis maintained a long correspondence with Jim Ede, the founder of Kettle's Yard in Cambridge, and wrote several less well-known letters to Ben Nicholson. We have taken this opportunity to publish these letters almost in their entirety.

Above all, this exhibition and accompanying book aim to celebrate and represent 'Two Painters', Alfred Wallis and James Dixon; two of the most interesting and singular twentieth-century artists in these islands.

The Irish Museum of Modern Art and the Tate Gallery St Ives are grateful to all who have worked on this project and especially to the many private and public lenders to the exhibition. We are grateful to the publishers Merrell Holberton, to the writers Matthew Gale and Richard Ingleby, and we are especially grateful to Dr Derek Hill, Chris Wilson at the Glebe Gallery, Co. Donegal and all the staff at Kettle's Yard, University of Cambridge.

Sarah Glennie Michael Tooby
Curator: Exhibitions Curator
Irish Museum of Modern Art Tate Gallery St Ives

"A star to steer her by"
The Spirit of the Sea in Twentieth-Century British and Irish Art
Richard Ingleby

I must go down to the seas again, to the lonely sea and the sky,
And all I ask is a tall ship and a star to steer her by,
And the wheel's kick and the wind's song and the white sails
* shaking,*
And a grey mist on the sea's face and a grey dawn breaking.

I must go down to the seas again, for the call of the running tide
Is a wild call and a clear call that may not be denied;
And all I ask is a windy day with the white clouds flying,
And the flung spray and the blown spume and the sea-gulls
* crying.*

I must go down to the seas again, to the vagrant gypsy life,
To the gull's way and the whale's way where the wind's like a
* whetted knife;*
And all I ask is a merry yarn, from a laughing fellow-rover,
And a quiet sleep and a sweet dream when the long trick's over.[1]

John Masefield, poet laureate, sailor and author of the above poem, was just thirteen years old when he first went to sea on a merchant navy school ship, soon after the death of his parents. He was not quite sixteen when he first rounded Cape Horn in 1894. On the one hand it is hard to imagine a lonelier life for a young orphan – the open sea is not a place for emotional fragility – yet, on the other, little could be more diverting or exciting than the prospect of a life on the ocean wave. This is the contradiction that sustains our relationship with the sea – a balance of childish adventure with the dread of its daunting power.

For the painters Alfred Wallis and James Dixon the sea was a fundamental fact, a part of daily life rather than a romantic idea, yet this essay begins with a poem because, even at its most unpoetic, poetry is what life by or on the sea is all about. Its language is intrinsically lyrical: a world of catheads and deadeyes, lubbersholes and futtocks; and as the Scottish poet and artist Ian Hamilton Finlay has so often demonstrated, the poetry can be found in the most ordinary places: from the salty lick of simple words – 'GREEN WATERS / BLUE SPRAY / GRAYFISH'[2] – to the names and numbers of fishing boats.[3] I should say at the outset that what follows is at best a subjective trawl through the waters of British and Irish art, if not quite a random one. No essay, not even a very long one, could do justice to the many thousands of artists who have made the sea their subject; this, then, is a personal selection, following a thread, I hope, from the 1920s to the present day.

'Sea Fever', quoted above, is John Masefield at his evocative best, though in fact his career at sea was short lived, as he was invalided out of the merchant navy soon after that first rounding of the Horn. The three years that he had spent on ship, however, were enough to make a poet of him, and his first volume, *Salt Water Ballads*, was published in 1902. The smell of the sea runs through much of his subsequent work, as it does through that of his friends the Irishmen W.B. Yeats and J.D. Synge, in an age when the romance of the sail was fast being replaced by steam. Synge in particular immersed himself in the subject, living for three years in a tiny fishing community on the Arran islands; a community whose daily tragedies were immortalized in his abrupt masterpiece, the play *Riders to the Sea*.[4]

The fascination with the sea was not, of course, confined to poetry and prose; in particular, the potential for dramatic shifts from calm to storm lent itself to the metaphors of music, notably in the work of Ravel and Debussy and, closer to home, in the *Sea Pictures* of Elgar and *Sea Symphony* of Ralph Vaughan Williams. In the visual arts, W.B. Yeats's brother Jack was drawn, like Synge, to the west coast of Ireland – the Ireland of his boyhood ("Sligo was my School and the sky above it"), a place where a living was hard won from the soil and the sea, and whose folk were the subject of so much of his best work (fig. 1). Inevitably, Yeats's view of it all, like that of his similarly inspired compatriot Paul Henry, was a

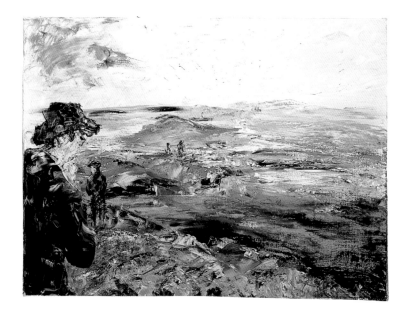

Fig. 1
Jack B. Yeats
Many Ferries
1948
oil on canvas
51 x 69 cm
National Gallery of Ireland, Dublin

romanticized one, and, for all his childhood memories, his vision remained that of the outsider, as, indeed, did that of Derek Hill, who worked in Donegal fifty years later, on Tory Island, an isolated finger of land nine miles off the coast.

Not so the vision of James Dixon, however, who was born and raised on Tory Island and for whom there was nothing at all romantic about the hardships of island life. Like most of the inhabitants of that remote place, Dixon was a crofter and fisherman, though, unlike some, he was in regular contact with the wider world as the captain of the boat that took mail to and from the mainland. The story of how he started painting, watching Derek Hill and deciding that he could do better, has been well recorded elsewhere, as has Hill's encouragement of his untutored skills. But, unlike Hill, who chose to visit Tory Island as a painting place, Dixon was faced by the inevitability of life on Tory as his subject – the only life that he knew.

Dixon's theme was not exclusively the sea – there are pictures of flowers, religious subjects, portraits and houses, and even a self-portrait – but its presence on all sides was inescapable, and on the occasions that he painted from memory or imagination (*The Sinking of the Titanic,* no. 56; or the wreck of *HMS Wasp,* no. 61) he was often drawn back to the ominous power of the sea as his subject.

Like Dixon, Alfred Wallis painted the world that he knew, or had known as a sailor and fisherman, though by the time he turned to painting he had been off the boats for many years. His life has become a sort of legend, and the story of his discovery, glimpsed painting at his table "... looking like Cézanne",[5] by the painters Christopher Wood and Ben Nicholson in the late summer of 1928, has been well told.[6]

Wallis's life was a simple one: he started out as a sailor, probably as an ordinary seaman in the merchant fleet and then finally as a fisherman. He married a woman twenty-three years his senior, and by 1902 he had set up as a dealer in marine stores, a rag-and-bone man in other words, on the wharf at St Ives in Cornwall. By the time Wood and Nicholson came across him he was a retired widower with just his Bible and his painting for company. As Ben's wife, Winifred, described him in 1928: "... he paints ... he distrusts people. He loves ships with a passion. All his painting is expressive as only great and simple painting is. His work had a great influence on Kit and Ben."

Much has been made over the years of this influence, especially on Christopher Wood, whose own delicate balance of naïveté and sophistication has been seen as owing a good deal to Wallis's way of working, though in truth Wood had

Fig. 2
Christopher Wood
China Dogs in a St Ives Window
1926
oil on canvas
63.5 x 76.2 cm
Private collection

Fig. 3
Ben Nicholson
St Ives Bay: Sea with Boats
1931
oil and pencil on canvas
40.9 x 56 cm
Manchester City Art Galleries

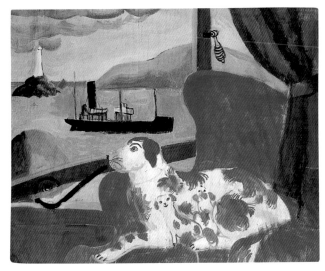
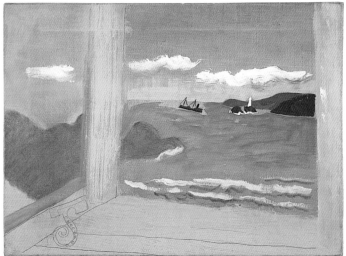

already begun to paint in this way by the time of his first visit to St Ives two years earlier. He had always been drawn to boats and the sea, and in such paintings as *China Dogs in a St Ives Window* (fig. 2) and *Ship Leaving a Cornish Port*, both of 1926, he was already employing the iconography of little ships and lighthouses that look so descended from Wallis.

Wallis did, however, provide a proof of the possibilities of a genuinely untutored hand and a pleasing link to another aspect of so-called 'primitivism' in which Wood and Nicholson were interested – the *ex voto* models of little boats pitched on stormy seas made by sailors to pass the time on long journeys. These had been the subject of an article in a 1927 edition of *Cahiers d'Art*,[7] a journal that both men knew, in which Yvangot, a naval officer turned art critic, described the models as "pure expressions of [the sailors'] souls". Next to these Wallis seemed every inch the genuine article: their very own Douanier Rousseau.

One very clear distinction between the paintings made by Nicholson and Wood in the late 1920s and the work of Alfred Wallis is the point from which they were painted. Wallis's boats are almost always viewed from the sea, a kind of aerial view across the waves, whereas those of Nicholson and Wood were always viewed from dry land (fig. 3). Wallis's view of things had the incidental effect of tilting the picture surface in a manner that echoes the flattened picture plane so beloved

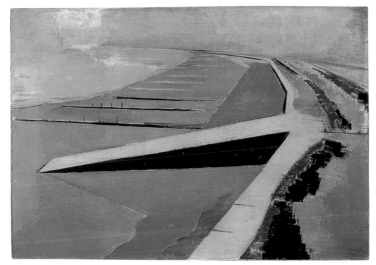 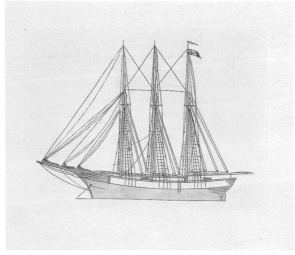

of modern European painting in the 1920s and 1930s. That, and the object quality of his deliberately uneven cards and boards, may also have had an effect, particularly on Nicholson's view of the world. As he said of Wallis some years later, "… one only finds the influences one is looking for … I was certainly looking for that one".[8]

Wood and Nicholson were not the only English painters to pursue a kind of seaside modernism in the 1920s. A number of their colleagues in the Seven and Five Society, the closest thing to a forward-thinking exhibition group in London at the time, were similarly inspired, namely Nicholson's wife, Winifred, and the Welshman David Jones. In a different vein, Paul Nash had discovered a poetic and melancholic beauty at the edge of the sea at Dymchurch on the Sussex coast (fig. 4), and Edward Wadsworth was giving a slightly surreal twist to his harbour-side tableaux of shells, ropes and navigational instruments, set against sharp blue skies. He was also the author of a series of copper-plate engravings gathered together as *The Sailing Ships and Barges of the Western Mediterranean and Adriatic Seas* (fig. 5), a simple homage to the line and form of beautiful boats, published in 1926.[9]

With the advent of the Second World War in 1939, Ben Nicholson returned to St Ives, thus ensuring the beginnings of the town's reputation as a centre of landscape – or frequently seascape-based abstraction – its power so often an underlying

Fig. 6
Margaret Mellis
Big Blue
1995
mixed media
120 cm high
Collection of the artist

Fig. 7
Graham Rich
Red Door (detail)
1998
found object, incised and painted
32 x 12 cm
Collection of the artist

presence in the work of such artists as Peter Lanyon, Bryan Wynter and William Scott, all of whom lived in or regularly visited the town. Nicholson's first home at St Ives when he returned in 1939 was just outside the town at Carbis Bay with the writer Adrian Stokes and his wife, Margaret Mellis, and it was these three who cleared the remaining paintings from Wallis's house at 3 Back Road West after his removal to Madron workhouse in June 1941.

Margaret Mellis (fig. 6) is a living link to that time and place and has recalled the journey home in Nicholson's car – Ben, as ever, immaculately dressed in blue-and-white-striped jersey, white peaked cap and a pair of white duck trousers. Before long the fleas began to find their way from Wallis's world into theirs, and, with screams of horror, Ben stopped the car and ran into the sea, where he remained for some time with water lapping around his neck, his peaked cap still in place, until he felt the coast was clear.[10]

These days Mellis lives on the Suffolk coast, where, for the last twenty years, she has made constructions out of pieces of driftwood found on the shore. It is a way of working that grew out of her daily routine of gathering firewood, a routine that changed when she saw a red-painted piece in the flames that looked too beautiful to burn. Once rescued it became the first of the many hundreds of bits of wood that have since been set aside as the material of her art. Something of the process harks back to the work she made in the early 1940s, when the Constructivist Naum Gabo lived next door, but the newer work has its own very distinct identity, not unrelated to the in-built history of her chosen material. Any sense of this is ignored in the process of making – "… my thoughts are simply engrossed in making it work", she has said[11] – but once completed she can turn her attention to the actuality of what it is that she had been looking at. Sometimes the results are totally abstract – constructivist exercises in colour and form – while others have a quirky, often witty, kind of figuration. Always they smack of the sea.

There is an inherent drama in driftwood as a material – a knowledge that it has been broken from a larger whole and an inevitability that the process of breaking was not a happy one; a hint of disaster. This is something that Wallis would have understood. As a rag and bone man plying a trade in salvaged goods, he had a keen sense of the necessity of destruction and recycling, and as a sailor he had a deep understanding of the elemental powers of nature. He probably witnessed the wreck of the *Alba* on the rocks off Porthmeor Beach on 31 January 1938, and certainly the stricken ship was very vividly in his mind when he made the paintings that bear her name.

The associations of driftwood are not lost, either, on Graham Rich (fig. 7), another artist who uses it, among other things,

Fig. 8
Will McLean
Fishing Boat with Flag
1989
mixed media construction
33 x 32 cm
Private collection

Fig. 9
Ian Hamilton Finlay
EVENING WILL COME THEY WILL SEW THE BLUE SAIL
1970
silkscreen
80.5 x 28 cm
Private collection

EVEN
-ING
WILL
COME
THEY
WILL
SEW
THE
BLUE
SAIL

as his basic raw material. Rich is a sailor and a traveller, a sailing artist in much the same way as Richard Long or Hamish Fulton are walking artists, a man whose journeys are the fuel of his art. He gathers wood along the way and makes his mark – the image of a gaff-rigged sloop – scratched into the surface of the painted driftwood at such a point, in such a way, that it describes a moment on the journey. Some are made *en route*, left as markers on the way, others returned to the sea, to be washed up at another time and place. "The found", he has said, with some cause, "... is more powerful than the made."

Which brings us back to the poetry and art of Ian Hamilton Finlay. Hamilton Finlay was born in Nassau in 1925 and brought to Glasgow as a young boy, his father having made and lost a fortune running a bootlegging schooner in the Bahamas. In 1939 he was evacuated to Orkney, which is where his own relationship with the sea began. Since then it has been a constant part of his life and work, even from the land-locked isolation of Little Sparta, the classical garden he has built in the Pentland hills and from which he never strays. Hamilton Finlay was first and foremost a concrete poet and all his other work stems from a fundamentally poetic view of the world – a view in which, to borrow Rich's words, the found is more powerful than the made and poetry lurks in the simplest of words and phrases: *EVENING WILL COME THEY WILL SEW THE BLUE SAIL* (fig. 9); or in a *diamond studded fishnet*; or the ultimately simple *star steer*.

Will MacLean (fig. 8) is another Scottish artist with a strong sense of the innate poetry of the sea and the ability to harness it in his work. As with Finlay, his father was a sailor, though of a rather different sort, serving as deck-hand, mate and master mariner before settling into the role of the Inverness Harbour Master. All the male members of MacLean's family were sailors or fishermen of one sort or another, and MacLean himself would have been bound for the sea had he not failed an eye test and so found himself at Grays School of Art in Aberdeen in 1961. Early on in his career he was commissioned to record a history of ring-net fishing in Scotland, a documentary project that gave him the visual vocabulary for the language of the sea that he has been speaking ever since. There is still in his work a balance of factual detail that ties the more imaginative elements to their place in the real world, a place that is steeped in the history and culture of the Scottish Highlands and Islands.

Fig. 10
Tacita Dean
Disappearance at Sea (cinemascope)
1996
colour anamorphic optical sound 14 mins
Courtesy the artist and Frith Street Gallery, London

Fig. 11
Garry Fabian Miller
The Sea Horizon
made in 1976–77, printed in 1997
31 x 31 cm
photograph, 3rd edition
Courtesy Michael Hue Williams Fine Art, London

Photography, by its nature, has a documentary element, though in the case of Thomas Joshua Cooper it is one with high romantic overtones. His black-and-white shots of the ocean, in which the camera seems to be just above and very close to the surface of the water, have the quality of freezing the natural flow, just for a second. They present fragments of something that we know is huge: details of an unimaginably vast and solitary whole. There is something of this in Garry Fabian Miller's *The Sea Horizon* (fig. 11), a series of forty photographs taken from a fixed point on the roof of his parents' house at Clevedon from 1976 to 1977. His subject – the meeting-point of sea and sky – and the equipment and technique (camera, lens and exposure) were unchanged from one photograph to the next, but the variables of time, weather and Miller himself, choosing his moment acording to his mood, determined the uniqueness of each image. It sounds very simple, but the cumulative effect is a complex and poetic one – a detailed exploration of the nature of time, place and especially light.

Miller is not unaware of the precedents that lie before him in choosing to make his work at the edge of the sea, or the edge of the land as it seems here. Specifically, he recalls the photographs of the American Edward Weston, which first drew his attention to the ready-made tension that lies along the horizon line, and to the detached mood of Paul Nash's Dymchurch paintings – "… a degree of aloneness",[12] as he describes it. I'd venture that there is another link, to the strange and melancholic poetry of Mark Rothko's 'horizon' paintings – abstract masses of balanced colour which are at once both deeply satisfying, yet full of an unspecified longing, a nostalgic yearning for something not quite grasped.

The documentary format has also been used as a way of packaging ideas by more conceptual artists working in a variety of different media. Among the most successful of these in recent years have been the films and story-boards of Tacita Dean. Much of her work since leaving Falmouth School of Art in 1988 has been inspired by the sea, especially by the details of actual events, such as the tragedy of Donald Crowhurst, the yachtsman who lost his bearings, his sanity and his life while sailing solo around the world in 1969. His was a pathetic slide from heroism to delusion, a modern-day version of Coleridge's *Ancient Mariner*, without the metaphorical bird life, and as such the perfect vehicle for Dean's disorientating combination of sound and vision in *Disappearance at Sea* (fig. 10). At other times Dean has been inspired by more easily

Fig.12
Dorothy Cross
Ghost Ship
February 1999
lightship, phosphorous paint and UV lights
Nissan Art Project in association with the
Irish Museum of Modern Art, Dublin

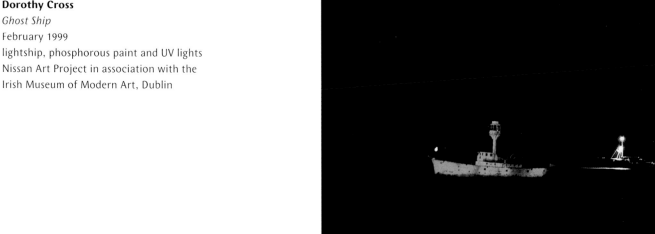

forgotten corners of history: *Girl Stowaway*, for example, began with a photograph of a girl in a book and became the story of Miss Jean Jeinnie, a girl who risked her life hiding in the hold of the *Hergozin Cecilie* from Australia to Falmouth in 1928 – a complicated riddle that drew Dean into the story in a most peculiar way, resulting in her being called as a witness in a murder inquiry at the place in Devon where the *Hergozin Cecilie* went down in 1936.[13] This, according to Dean, is the meandering line of history "... the line that divides fact from fiction", and which has dominated so much of her work in recent years.

The line dividing fact and fiction in Dean's work is the horizon that runs between appearance and reality and on which Dorothy Cross's *Ghost Ship* (fig. 12) balances, a haunting reminder of Ireland's maritime past. I have mentioned the inherent drama of driftwood in relation to Margaret Mellis and Graham Rich, but in *Ghost Ship* Cross took the notion of beach-combing to its absolute conclusion by claiming, if only for a short while, an entire boat as the medium for her message. The boat in question was an old lightship, one of the original engineless vessels that were once anchored to the seabed of the Irish coast – like stars to steer ships to safety. Cross painted her ship with light-charged phospherous paint so that its silhouette glowed a ghostly green in the dark of Dun Laoghaire bay, fading slowly as the phospherous lost its charge. It was a tribute, in her mind, to the memory of the lightships and to an era when the sea played a greater part in Irish life – a ghostly echo of Dixon's *Wasp* (no. 61) and Wallis's *Alba* (nos. 28 and 29) and any and every ship that has set sail and not returned to port. It is a powerful and evocative image and, for all the temporary nature of the work itself, an enduring one.

Notes
[1] John Masefield, 'Sea Fever', 1912.
[2] Ian Hamilton Finlay, *The Blue and the Brown Poems*, 1968.
[3] See, for example, Ian Hamilton Finlay, 'Sea Poppy', 1966, and the sculptures *Starlit Waters*, 1967–68.
[4] *Riders to the Sea* tells the story of an old woman, Maurya, and the loss to the sea of the last of her six sons.
It was first performed at the Molesworth Hall, Dublin, on 25 February 1904.
[5] Wood's description, quoted in Richard Ingleby, *Christopher Wood: An English Painter*, London (Allison & Busby) 1995, p. 192.
[6] Most recently by Mathew Gale, *Alfred Wallis*, Tate Gallery Publishing, 1998.
[7] *Cahiers d'Art*, no. 4–5, 1927, quoted in Ingleby, *op. cit.*, p.193.
[8] Ben Nicholson to Ronald Alley, 27 July 1962.
[9] Published in an edition of 450 copies at the Curwen Press in 1926.
[10] Margaret Mellis in conversation with Richard Ingleby, April 1998.
[11] Margaret Mellis in conversation with Richard Ingleby, May 1999.
[12] Garry Fabian Miller in conversation with Richard Ingleby, May 1999.
[13] As recorded in Virginia Button's essay for the Tate Gallery, Turner Prize, 1998.

Artistry, Authenticity and the Work of James Dixon and Alfred Wallis
Matthew Gale

In late 1923, Luigi Pirandello's play *Six Characters in Search of an Author* was given its Parisian première.[1] Its plot deals with various relationships to reality, encapsulating the uncertainties of modern life. The play opens with a director and his troupe in rehearsal. They are soon interrupted by the six characters, who carry the burden of a collective family crisis, which they continually relive and which they are seeking actors to act out and expiate. Learned formulae are thus contrasted with poignant experience, and it is this that provides a parallel for the relationship between professional and untrained artists, the so-called 'modern primitives'.[2] Like Pirandello's confrontation of actors and characters, the encounters between artists and primitives resulted in an unlearning of conventions by the trained in the face of these personal views of reality, independently expressed. In essence, this reflected the prevailing concerns and currents of industrialized society, which ensured that authenticity was valued over artistry. The apparent simplicity of this value system belies the complexity of the relationship born of encounters between professional artists and such painters as Alfred Wallis and James Dixon.[3] Aspects of these relationships between the participants will be examined here.

So seductive was the call of the simple life that a number of artists sought to become 'primitive' themselves. The example of Paul Gauguin is often cited, although his primitivizing art is recognizably based on a whole swath of learned sources. In the twentieth century there were also artists within the mainstream of Modernism – such as Marc Chagall – whose work was at various times considered primitive.[4] Christopher Wood is another of these, as his painting is often described as naïve. This exposes the inadequacy of the terms, as he (who trained briefly as an architect and was encouraged to study art in Paris by Augustus John and Alphonse Kahn) and Wallis (the retired rag-and-bone dealer from St Ives) clearly enjoyed different circumstances. It is telling how the badge of untrained artist was proudly worn by professionals, reflecting the view of art education as a crushing weight. It was in these circumstances that the search for authenticity was undertaken.

It seems clear, even from the most cursory investigation, that the relationship between the modernist and the primitive is an uneven one. This is typified, above all, by the notion of 'discovery'. Although it could be argued that the self-determination of the 'discovered' people is understood, the term conveys the action of one dominant party on the dominated 'other'.[5] In the series of mythologized encounters with living artists down the years, an imbalance of power is implicit, as various scholars have pointed out, so that the relationship with such 'primitives' or 'outsiders' is viewed from an assumed cultural centre.[6] It may go unrecognized that more is revealed of the discoverers than of the producers in this self-reflexive process.[7]

The historical yardstick for this relationship is Henri 'le Douanier' Rousseau, who was admired by Gauguin, Odilon Redon

Fig. 13
Orneore Metelli
Procession and Town Festival
1938
oil on canvas
126 x 64.7 cm
Sprengel Museum, Hannover

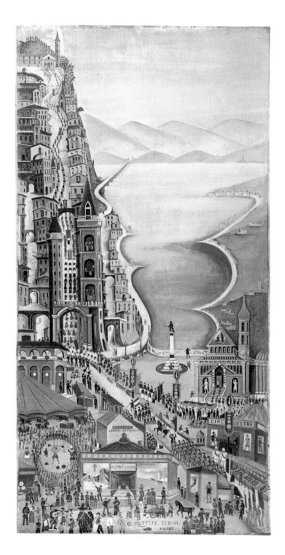

and Alfred Jarry in the 1880s and 1890s before being taken up by the younger generation of Pablo Picasso, Georges Braque, Robert Delaunay and others.[8] Rousseau is seen as the first and most outstanding example of an artist working in the midst of the modern world but in some respects detached from its realities. In this way he was dubbed with another contentious term, 'naïve'. His biography establishes many of the prerequisites repeated elsewhere. He was engaged in a socially inferior capacity, his painting was dismissed in official circles and he worked as a 'Sunday painter' in relative isolation, apparently producing his art out of an inner compulsion rather than for commercial gain. Significantly, his struggle – with which his avant-garde supporters identified – reached fruition after retirement and could be understood as the result of years of repressive conformity.

The promotion of Rousseau's work by avant-garde artists before and after his death in 1910 is echoed in comparable situations across the Western world.[9] It was parallelled by Niko Pirosmanashvili's contact in Georgia in 1912 with the circle of Ilya Zdanevich and the Russian painters Mikail Larionov and David Burliuk.[10] In post-war France, André Bauchant was 'discovered' by the Purist Charles-Edouard Jeanneret (the architect Le Corbusier), and Séraphine Louis by Wilhelm Uhde (one of Rousseau's main admirers), while Orneore Metelli (fig. 13) was promoted in Italy by Aurelio De Felice. Thus, when Ben Nicholson and Christopher Wood 'discovered' Wallis in 1928, and Derek Hill 'discovered' Dixon around 1960, all were participating in a well-established pattern. Its repetition across the years exposes these discoveries as, in effect, meaning 'introduced into the system'. The Modernists brought the primitives to a wider public by establishing the climate for the acceptance of such work. Whether or not they stood to gain materially, the Modernists established their association with this raw creativity.

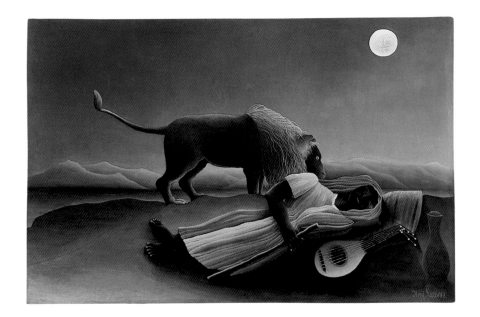

Fig. 14
Henri Rousseau
The Sleeping Gypsy
1897
oil on canvas
129.5 x 200.7 cm
The Museum of Modern Art, New York
Gift of Mrs Simon Guggenheim

With the emphasis on a prized authenticity, the concomitant of discovery was corruption. Once introduced into the system. the modern primitive was threatened by its demands, much as Gauguin's Tahiti was overwhelmed by European diseases. From this stems the uncertain relationship between primitivism and tourism, between compulsion and responding to expectations. These problems are central to what may be termed (rather inelegantly) 'mascotism': the absorption by a particular group of the work and myth of a modern primitive. The relationship is always uneven, with the professional artist – however sincerely – assuming a position of power. The myths that accumulate around the primitive artists exaggerate their distance from the mainstream; they are gathered by the discoverers, who often emphasize their own privileged relationship so that their assumptions determine the understanding of the 'mascot'. The resulting myth may be viewed as a means of protection from the corruption of the wider world, but the very assumption of this protective role is paternalistic and reinforces the view of the modern primitives as 'childlike' both in their art and in their approach to life. Typical of this is the denial of development in the artists' work, so that they may be construed to stand outside style and, nostalgically, outside time; the dating of Wallis's work was considered unnecessary, and it has been said of Dixon that there is "little difference to be seen in technique between the dates when he was at work".[11] Such an attitude is a hallmark of myth, for, as Barthes has noted, "Myth deprives the object of which it speaks of all History".[12] It should be understood that these attitudes reflect wider pressures and that the sincerity with which those concerned hailed the creativity of a fellow artist should not be in doubt. The need for the authentic in an era of mechanization and political upheaval underlies the more specific debates about the nature of expression in twentieth-century art.

If the summary list of discoveries provides evidence that there was a positive search for such artists, especially in the inter-war years, the immediate impetus was surely the commercial success of Rousseau's work. *The Sleeping Gypsy* (fig. 14), a work rediscovered in 1923, sold for an unprecedented price to the American collector John Quinn in 1926. Swept along on the 1920s' art boom, this may be seen as the high-water mark of the acceptance of 'primitive' work into the cultural mainstream.[13] Rousseau's prominence obscured the reputations of some and bolstered those of others. Once accepted, the promotion of his art could take on a nationalistic aspect as evidence of the inherent creativity of the French. The work of younger compatriots – such as Bauchant, Bombois and Vivin – was enlisted to this cause,[14] just as the prehistoric cave paintings at Lascaux achieved special significance when uncovered during the German occupation. Thus, despite the internationalist ideals often associated with Modernism, the search for similar examples of modern primitives elsewhere also took on a nationalistic aspect by example and by reaction. A measure of this attitude may be found in the fact that Wallis was first presented to the French public by Herbert Read as "sincerely 'naïf' – much more so than the Douanier Rousseau", and that, thirty years later, Dixon's art could be termed "as untutored as any one could find in Europe today".[15]

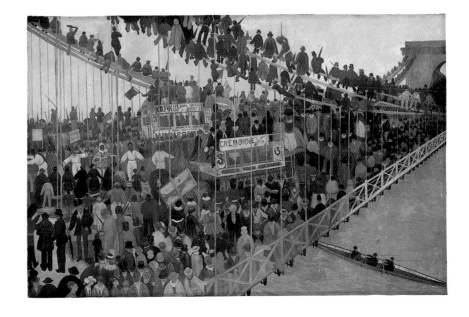

Fig. 15
Walter Greaves
Hammersmith Bridge on Boat Race Day
1862
oil on canvas
91.4 x 139.7 cm
Tate Gallery, London

Whatever the differences (and there were many), the parallels between Wallis and Rousseau have been recognized since the 1920s and, as Read's comment confirms, used as validation. Their role as mascot to their respective professional friends can be seen to come through even in the stories associated with their tombs. Both were made by these admirers to save them from paupers' graves, as well as to commemorate and distinguish them. Brancusi and Ortiz de Zarate inscribed Rousseau's tombstone with a poem by Apollinaire, while Adrian Stokes, Ben Nicholson and Barbara Hepworth were among those who made a financial contribution to the terracotta tomb of Wallis made by Bernard Leach.[16] These commemorations were heartfelt and underline the dead artists' acceptance into the community of the avant-garde. By the same token, these tombs may be seen as consolidating the myth; the absence of ordinary friends in these accounts reinforces the special status of the Modernists' recognition of the artists' work. In Wallis's case, there are accounts of his saving for his burial, but the magnanimity of Stokes's gesture in securing a plot overrides this knowledge of the painter's self-subsistence.[17] Indeed, it is never asked whether Wallis had any desire to be isolated in death in this way. Charming though his tomb is, it may be understood as a definitive appropriation of the artist from the local community by a group for whom that relationship carried other meanings.[18]

In these circumstances, the distinction between appropriation and protection is especially difficult to make. It has long been known that it was Rousseau himself who fashioned his own position in the art world (by exhibiting at the annual Salon des Indépendants from 1886) and that, whatever his support from the avant-garde, he maintained a self-assured sense of the worth of his work as art. A comparable case can be made for Pirosmanashvili, who earned his living as a sign-painter and carried an equally strong conviction of the worth of his own massive conceptions drawn from national epics.[19] By contrast, an alternative yardstick is offered by the example of the London waterman Walter Greaves, who decorated his father's boats until meeting James McNeil Whistler in the 1860s and being encouraged to emulate Whistler's style. There is some uncertainty whether Walter Greaves's *Hammersmith Bridge on Boat Race Day* (fig. 15) was painted before this meeting but there is little doubting its ambition and foundation in local experience. His career, however, is important as a cautionary tale. Most of his work was self-consciously indebted to Whistler, but when Greaves had an exhibition in 1911 acclaim was soon followed by accusations of faking.[20] It is significant that artists helped to sustain Greaves through this period and significant, too, that among them was William Nicholson, Ben's father. It hardly seems fanciful to speculate that Ben Nicholson's relationship with Wallis was in some respects circumscribed by his father's knowledge of Greaves, especially as the latter's non-Whistlerian work received its vindication in 1922, with the purchase for the nation of *Hammersmith Bridge on Boat Race Day*.[21] That experience may have aided the spark of recognition of Wallis's work in 1928, but may also have dictated the cautious nurturing of it over the following years. Wallis was not disentangled from his

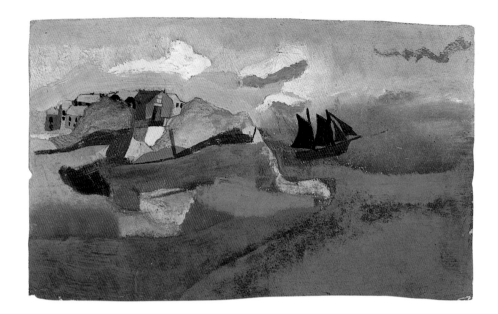

Fig. 16
Ben Nicholson
Cornwall
1928
oil on card
21.5 x 35 cm
Kettle's Yard, University of Cambridge

milieu in the way that Greaves had been; instead, geographical distance maintained his isolation. On the face of it, Nicholson (fig. 16) avoided the tutoring that Whistler had imposed in an earlier era,[22] so the lesson of Greaves's difficulties may have acted as a guide.

There is, however, some evidence of intervention. Within months of their first encounter, Nicholson had sent two illustrated books to St Ives. One was F.W. Wallace's *In the Wake of the Wind Ships*, the other a book on Rousseau, the paradigmatic 'modern primitive'.[23] Wallis's comment that the Frenchman knew nothing about boats was reported by Christopher Wood, but this criticism confirms that the St Ives painter had in some way measured his own work against this example.[24] While it is not surprising that Nicholson and Wood immediately drew this comparison, the book might be interpreted as nurturing a particular direction in Wallis's work. In the context of his reputed isolation it introduced a range of specific visual ideas in a way that threatened to be corrupting in just the same way for which Whistler was criticized over Greaves.[25] Even though it cannot be doubted that Nicholson and Wood recognized the fundamental technical and stylistic differences, it may even indicate a hope that Wallis's response might rival Rousseau's work.

This peculiar development contrasts rather interestingly with a debate, which Nicholson reported in his posthumous salute to the St Ives painter. Writing of Wallis's approach as "so childlike", he proposed that it might be "supposed that his severe selection of a few colours was purely unconscious". However, recalling an occasion when the painter had asked for "rock-colour and sand-colour", Nicholson continued: "Kit Wood remarked that it might easily spoil his work to give him new colours when so much of its point depended on the use of a few, but it seemed to me since he had asked for them he must be ready to deal with them."[26] Nicholson added that a new painting was made "using, of course, rock-colour for anything but rock and sand-colour for anything but sand".

Nicholson's account is significant for a number of reasons. It plays up, for instance, the reputation of Wallis as an artist who was spontaneous in his work and even childish in his description of the colours, and it adds Nicholson's knowing recognition of a wilful creativity ("rock-colour for anything but rock"). Its more startling aspect lies in the remark attributed to Wood, the underlying premise of which was that Wallis could be making paintings in a way that was outside his control.[27] As professionals (or so the reasoning appears to go), Wood and Nicholson had a responsibility to protect Wallis from himself and to prevent him from technical risk-taking. This suggests that they momentarily considered withholding paint because they thought his demand unwise. Quite apart from the possibility of Wallis buying the paint himself, as he had done before their arrival, this shows a paternalism that is little short of condescension. Nicholson's reported response

Fig. 17
Derek Hill
Tory Island from Tormore
1958
oil on canvas
71.2 x 122 cm
National Museums and Galleries
of Northern Ireland

is quite reasonable, but even it implies that if he had doubted Wallis's readiness he would have sided with Wood. Such an analysis may appear harsh, especially in the context of Wallis's vast productivity, which suggests a profligacy of industry rather than the studied doggedness of Rousseau. However, it does expose the tendency to treat the author of "childlike" images as a child.

Some justification for this attitude is found in the judgements demanded by the untrained artists from those professionals whose friendship and opinion they obviously admired. The stories of Wallis sending packages of works to Nicholson and to Jim Ede are directly parallelled in stories about Dixon. In both cases, the admirer was invited to make definitive judgements about the success of the work. Unsuccessful or unwanted paintings were simply sent back to Wallis.[28] Similarly, Derek Hill (fig. 17) cited the rush of Dixon's productivity, reporting in 1966 that, of the Tory Island painters, "Jimmy is the most prolific, and when a new bundle [of paintings] arrives for me to sort over for him, they are often still wet and stuck together".[29] Thus they appeared to demand editing, and the surviving works must, to some extent, reflect Hill's selection. Although it seems problematic to extrapolate from this account a lack of self-criticism on Dixon's part,[30] the process appears to have been a judicious mediation between the painter and his public.

Like those of his predecessors, Dixon's artistic style and biography have melded into a confirmation of authenticity. "The clumsiness may be called child-like or primitive but it is true", Hill wrote, "and intimately related to the place where the pictures have been painted."[31] Training (or lack of it), occupation (farmer and fisherman) and the extreme location combined to guarantee the work. The particular social situation of Tory Island distinguishes the circumstances of Dixon and his colleagues there who also took up painting: his brother John Dixon, James Rodgers and Patsy Dan Rodgers.[32] While some of the authenticating qualities are shared by others, Dixon's encounter with Hill was determined by a different artistic context from those links established earlier in the century. Hill was already aware of the precedents and knew the work of Wallis and Pirosmanashvili.[33] Furthermore, the activities of Jean Dubuffet in post-war Paris in promoting 'Art Brut' – the art of the untrained outside the norms of society – had revolutionized the reception of the 'primitive'. Much of the work gathered by Dubuffet was rougher in style and more personal in imagery than that spawned by Rousseau. It was in this stylistic context that Dixon's work gained a wider acceptance; indeed, the marked abstraction of many of his compositions closely echoed the developments in contemporary European painting.

The encounter with Hill appears to be a whimsical moment of challenge by Dixon, marking his inception as an artist. This was not exactly the case. He had already made paintings in the 1950s, notably of Wallace Clark's yacht, and Hill's account

Fig. 18
André Bauchant
Funeral Procession of Alexander the Great
1940
114 x 195 cm
Tate Gallery, London

suggests a developed technique in Dixon's preference for paper and home-made donkey-hair brushes.[34] Furthermore, his skills were signalled at a much earlier stage by his marquetry writing-case made in 1911. This echoes the stories of Wallis drawing long before the date at which he is supposed to have begun to paint, as well as the experience of Orneore Metelli as a prize-winning shoemaker before he turned to depicting the activities of his city. All may be considered as examples of craftsmen whose skills had served their communities before turning to painting as a means of chronicling those same societies.[35] If these artists were significantly productive before their respective 'discoveries' – a factor that is, after all, necessary to that encounter – then the myths surrounding them require modification. They were not so naïve as to lack practical skill, which they channelled towards the production of images. Perhaps less deliberate than Rousseau or Greaves in seeking a public outlet for their art, such artists as Metelli, Wallis and Dixon were nevertheless self-consciously making work that aspired to something more evocative than could be achieved in the crafts or hobbies that they had earlier practised. It is the ambition that was nurtured by the professionals whom they encountered.

A measure of this ambition is found in the aspiration towards the epic. Perhaps most extreme in this respect was André Bauchant (fig. 18), whose work was concentrated on historical themes. Like Rousseau, his compositions recast the orthodoxies of high art in a personal style at some distance from the academic; it may be these recognizable aspects that

Fig. 19
Niko Pirosmanashvili
Childless Millionaire and Poor Woman with Children
oil on waxcloth
114 x 156 cm
State Museum of Art, Tblisi, Georgia

made the paintings so readily acceptable. For other artists, the search for the epic has roots in the artistic and oral traditions of the region, which they continue to visualize. Pirosmanashvili's exploration of Georgian poetry is a prime example, though he brought the same sense of gravity to issues prevalent in his own time (fig. 19). While Wallis and Dixon may appear to have avoided such rhetorical subjects, both made a number of spiritually charged works: Dixon's *Ave Maria* (no. 43) transformed a local devotional statue, while Wallis's *Crucifixion* (or *Allegory*) is altogether more obscure. More frequently, both artists showed a propensity for grand themes. Wallis's repeated depiction of the wreck of the *Alba* (nos. 28 and 29) brings to the surface the elemental struggle which is more concealed in other works.[36] The common theme of the sea ensures that wrecks also feature in Dixon's work, from the local wreck of *HMS Wasp* (an excise ship said to have been cursed by the Tory islanders; no. 61) to the famous *Sinking of the Titanic* (no. 56).

On one level these works tackle issues pertinent to the local communities, and their sense of drama must be circumscribed by Dixon's protestation that "there is nothing romantic about little boats fighting with crashing waves and winds".[37] There is a claim here for the unadorned reality of experience. On another level, by tackling famous incidents with the authority of a specialist, these works embody reflections on the cultural centre from 'outside' that mainstream. In ambition, they break the division while they confirm it in their style. In holding a mirror up to the dominant culture in this way, modern primitives in the middle of the century offered a regeneration of attitudes (towards history, history painting, social commentary) often abandoned by the very Modernists who supported them.

It will not have gone unnoticed that Dixon's statement contains a paradox, and one of which it is likely that he was aware. In denying the romanticism in the harsh reality of seafaring he pinpointed the fact that, for those who did not have to risk the experience, it was the romance of that struggle that made Tory Island stimulating and attractive. This is the quality that had brought Hill (fig. 20) and others there to paint and that had similarly ensured a greater tourism in Cornwall for a century or more. The rural and the elemental are the magnets for visitors who marvel at those bound to daily survival in these circumstances. The paintings of storm-lashed ships and wrecks, for which there is a substantial tradition, thus take on a further function in the work of Wallis and Dixon. They absorb the events into local folklore and remake them for distribution. Wallis, who reputedly painted six days a week, showed an awareness of these expectations in writing of works for the "summer season" or for sale "inland".[38] Dixon, who dated and inscribed his paintings so informatively, seems to have worked in bouts and, whether consciously or not, to have responded to similar demands. Seen in this light, the compulsion to paint and the chronicling of local life combine to meet the expectations of an audience willing to see only the romance of life on the physical and cultural fringe.

Fig. 20
Derek Hill
The Back of Tory Island
1960
oil on canvas
152.5 x 122 cm
Bank of Ireland

The phenomenon of 'modern primitives' peaked in the first half of the twentieth century. Setting aside the differences ensured by their individuality, they detailed past and passing events and were united by a pervasive conservatism that underlay even the depictions of contemporary subjects. The wide support that their work eventually found (often posthumously) may also be seen as conservative. The charm of Rousseau's beasts, Wallis's boats or Dixon's tethered sheep excuses any shortcomings perceived by a receptive public. Between these positions lies that of the professionals who sponsored such artists. Their search for renewal outside conventional art forms was a revolutionary step in terms of style and aesthetic, but, it may be argued, even this was burdened with nostalgia, as it carries redemptive and pre-lapsarian associations. The search for authenticity can be an impulse, but it can also be a counterpoint to change. It is notable that Nicholson, whose relationship with Wallis appears exemplary in this respect, had moments of close involvement and moments of detachment and that these reflect his oscillation between realism and abstraction in his own work as well as his responses to the changing relationship of art to modern life. In the period of his commitment to an international Constructivist art during the mid-1930s, his engagement with Wallis's work was reduced, only to be resurgent in the enforced evacuation of the wartime years.

The authenticity provided by such artists as Wallis and Dixon validated an escape into the past, which was reassuringly familiar but freshly expressed. The works are often said to speak for themselves in this respect, but myth and expectation have tended to drown this out. It would be rash to assert for them any single reading based on a speculative reconstruction of the artists' intentions. Instead, to recognize the accumulation of commentary around them and to tease out some of its strands allows us to explore how the relationship between professionals and modern primitives functioned. To recognize the layers of meaning involved is a step towards clarifying the nature of the exchange between the artist and the audience.

Notes

[1] *Sei carateri in cerca di un autore*, originally staged in Rome in 1921, revised for production by Pitoëff in Paris in 1923.

[2] This term is undeniably contentious. Coined around the turn of the century, 'modern primitives' denotes those artists working largely outside artistic systems (training, market, exhibitions *etc*) though not exclusively so. That it could be synonymous both with 'Sunday painter' and 'naïve artist' indicates its vagueness. It has the advantage of signalling (however inadvertently) the inscription of these artists within a modernist ideology. The related term 'outsider' – with psychological and pathological overtones – seeks to define the individual in contrast to Modernism. For discussions of some of these issues see: David Maclagan, 'Outsiders or Insiders' in Susan Hiller (ed.), *The Myth of Primitivism*, London and New York 1991; and Roger Cardinal, 'Towards an Outsider Aesthetic', and Eugene W. Metcalf Jr., 'From Domination to Desire: Insiders and Outsider Art', both in Michael D. Hall and Eugene W. Metcalf Jr. (edd.), *The Artist Outsider: Creativity and the Boundaries of Culture*, Washington, D.C., and London 1994.

[3] For Wallis see: Sven Berlin, *Alfred Wallis: Primitive*, London 1949, rev. Bristol 1992; Edwin Mullins, *Alfred Wallis: Cornish Primitive Painter*, London 1967; and Matthew Gale, *Alfred Wallis*, London 1998, in which some of the themes explored here were touched upon. For Dixon see: *James Dixon*, exhib. cat. by Derek Hill, London, Portal Gallery, 1966; and Aiden Dunne in *Tory Island Painters*, Dublin (Arts Council of Ireland) 1982. I should like to thank Derek Hill for making time in his busy schedule to discuss some of these issues with me.

[4] Other artists who have been described as 'primitive' include Maurice Utrillo and L.S. Lowry. It should be noted that 'Modernism' is capitalized in this catalogue in accordance with common usage rather than for strictly theoretical reasons.

[5] A precedent is found in the rediscovery around 1900 of the 'Italian primitives', as the art of the Trecento of Giotto and Duccio was known at the time, by such scholars as Bernard Berenson, and which was taken up in the avant-garde by such artists as Carlo Carrà, who wrote small monographs on both Giotto and Henri Rousseau.

[6] See Kenneth Coutts-Smith, 'Some General Observations on the Problem of Cultural Colonialism', 1976, republished in Hiller (ed.) 1991, and especially Eugene W. Metcalf Jr. 1994.

[7] See Eugene W. Metcalf Jr. 1994, p. 222.

[8] See William Rubin and Caroline Lanchner, 'Rouseau and Modernism' in *Rousseau*, exhib. cat. by Rubin and Lanchner, New York, Museum of Modern Art, 1984.

[9] See Coutts-Smith 1991 for discussion of the cultural colonialism embodied in notions of the 'primitive'. The 'other' represented by the primitive is, necessarily, seen as distinct from the standards of a dominant Western art. It is because of this paradigm that the relationships to folk art and to 'traditional' arts of non-Western cultures continue to be problematic.

[10] Pirosmanashvili is also known as Pirosmani.

[11] Mullins 1967, p. 14, considered the dating of Wallis's work "a pointless art historical feat"; see Gale 1998, ch. 3; see also Derek Hill, 'James Dixon', *Irish Arts Review*, 1993, p. 179.

[12] Roland Barthes, 'Myth Today', *Mythologies*, London 1973, p. 151. I should like to thank Chris Stephens, who read a draft of my essay and suggested this addition.

[13] For *The Sleeping Gypsy*, see Rubin and Lanchner 1984, pp. 60–62, 140–41.

[14] See Jean Cassou in *Masters of Popular Painting*, exhib. cat., New York, Museum of Modern Art, 1938.

[15] Herbert Read, 'L'Art Contemporain en Angleterre', *Cahiers d'Art*, no.1–2, 1938, p. 31; Derek Hill 1966.

[16] W.S. Graham's poem, 'The Voyages of Alfred Wallis', 1948, serves as an echo of Apollinaire's salute.

[17] As Wallis seems to have lacked any other income it seems reasonable to assume that the savings came from the proceeds of the sale of his paintings.

[18] Even Rousseau's position carried the suggestion of paternal 'mascotism'. He was both honoured and mocked at a banquet in Picasso's studio. The inaccuracy of the epithet *'douanier'* – meaning a customs official – when he was a more lowly *'gabelou'* – suggests a gentle flattery by these artists.

[19] See S. Amiranashvili, *Niko Pirosmanashvili*, Moscow 1967, and *Pirosmani*, exhib. cat., Namur, Maison de la Culture, 1997.

[20] See Tom Pocock, *Chelsea Reach: The Brutal Friendship of Whistler and Walter Greaves*, London 1970.

[21] It is notable that the Seven and Five Society met in William's studio under Ben's presidency in 1928 and 1929. Greaves featured in John Rothenstein, *Artists of the 1890s*, London 1929.

[22] Despite their differences, Whistler's attitude may be compared to Ruskin's view of the betterment of the working classes through art.

[23] See Gale 1998, pp. 23, 25, 70. Although it is not certain which book on Rousseau this was, it is likely to have been Roch Grey's (pseudonym of Helen d'Oettingen), *Douanier Rousseau*, Rome 1924, Eng. trans. 1926. This seems to have been published to coincide with the first exhibition of Rosseau's work in London, at Alex. Reid and Lefevre in October 1926.

[24] Wood to Winifred Nicholson, 28 October 1928, Tate Gallery Archive 8618.

[25] See Pocock 1970, p. 169, and George Melly, *A Tribe of One: Great Naïve Painters of the British Isles*, Yeovil 1981, p. 20.

[26] Ben Nicholson, 'Alfred Wallis', *Horizon*, 7, no. 37, 1943, pp. 50–54.

[27] This was couched in technical terms rather than the terms of Surrealist automatism by which some visionary artists would be judged, and with which Wood was familiar through his friendship with René Crevel. The urgency of depiction which approached automatism was often attributed to the psychotic and visionary artists promoted by Jean Dubuffet as Art Brut in the post-war period.

[28] Exemplified by Nicholson's letter to Wallis, 18 February 1929, quoted in Berlin 1992, pp. 56–57. There is the suggestion that Wallis reworked them and offered them again; see Gale 1998, p. 29.

[29] Hill 1966. Inspection of the works confirms the sticking together, which may also result from the saturation of the paper with oil paint.

[30] Chris Bailey in *James Dixon: A Retrospective Exhibition*, exhib. cat., ed. William Gallagher, Co. Donegal, Glebe Gallery; Cork, Boole Library, University of Cork; 1990.

[31] Hill 1966.

[32] This sense of a group of untrained painters working in friendly rivalry is distinct from the isolation ascribed to most 'modern primitives' and might be compared to the more structured and politically inspired circumstances of the miners of the Ashington Group in England; see William Feaver, *Pitmen Painters: The Ashington Group*, London 1988.

[33] In conversation with the author, March 1999; Hill recalled becoming aware of Pirosmanashvili's work in the USSR in the 1930s, when he was also interested in the legendary icon painter Andrei Rublev.

[34] Hill 1966.

[35] Hill has described Dixon as "entirely concerned with the island and with what he had seen there during his lifetime", in *Tory Paintings in Irish Houses*, exhib. cat. by Derek Hill, Kilkenny, Kilkenny Art Gallery, 1972.

[36] The story of the wrecking off Porthmeor Beach in January 1938 was of national and international scope, being reported on the radio and involving the foreign crew; see Gale 1998, pp.64–66.

[37] Quoted in Hill 1993.

[38] In 1933–34; see Gale 1998, p. 29.

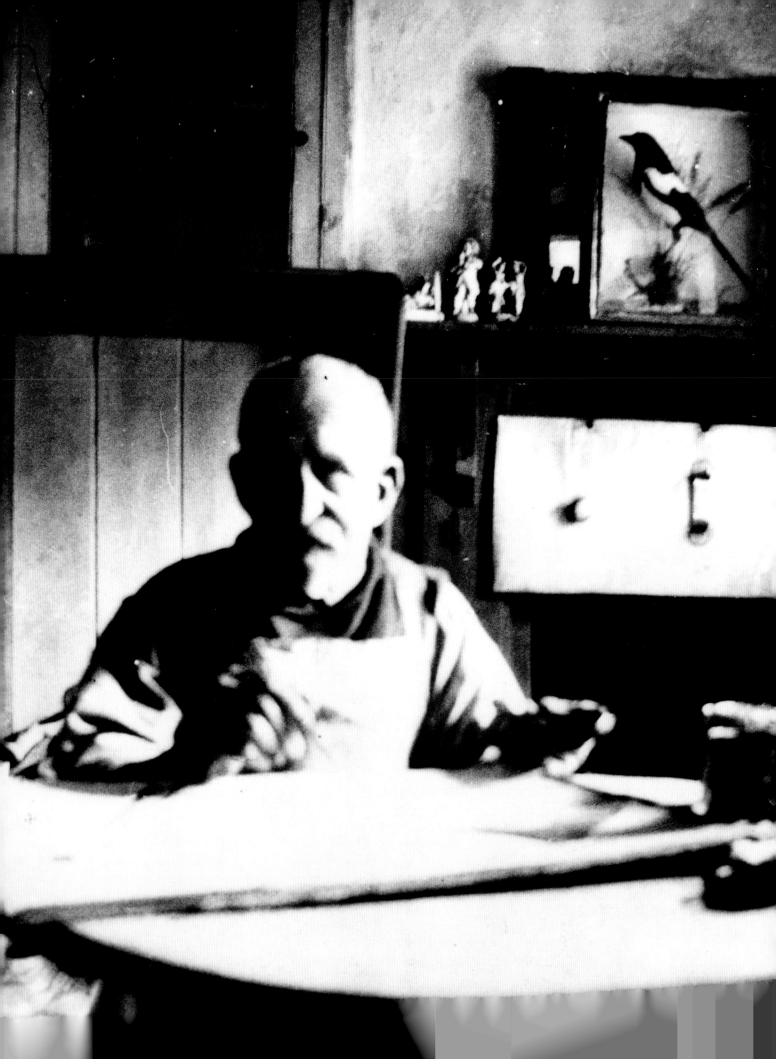

Alfred Wallis
Biography and Selected Exhibitions

1855 Born 8 August at 5 Pond Lane, Devonport, near Plymouth.

1871 Wallis is listed in a census as an "apprentice basket maker".

1876 Married Susan Ward, a widower who already had several children. He was twenty and she was forty-three. Alfred and Susan had two children, both of whom died in infancy.

In 1876 Wallis gave his profession as a "Mariner, Merchant Service", and there is evidence that he crossed the Atlantic as he is on the crew lists for the *Belleventure* which he joined in Newfoundland, disembarking in Teignmouth, Devon. Sven Berlin stated that Wallis went to sea as a cabin-boy at the age of nine but there is no evidence to support this.

1887 Moved to St Ives, Cornwall, with his wife and her family.

In 1887 Wallis's business was listed as "Marine Stores Dealer, Back Road, St Ives": Wallis moved it to the Wharf in 1902 (see p. 123). The business supplied basic marine equipment but mostly dealt in second-hand and salvaged goods, which earned him the reputation of being a rag-and-bone man.

1908 Bought 3 Back Road West, St Ives.

1922 Susan Wallis died.

1924 Sold the cottage at 3 Back Road West on condition that he could go on living there until he died. It appears that he was in financial difficulty from 1912 until his death, as it is registered at several official records that he had difficulties paying his taxes.

1925 Began to paint using brushes and household paint bought in St Ives. He painted on scrap pieces of card (the works on canvas were probably painted over other artists' compositions, often incorporating aspects of the original, for example *Shy Lover*, no. 19).

1928 Wallis met Ben Nicholson and Christopher Wood. The meeting is documented in Ben Nicholson, *Horizon*, 7, no. 37, 1943, pp. 50–54. *The Schooner and the Lighthouse* (no. 1) was one of the paintings taken by Ben Nicholson from the meeting.

1929 Included in Seven and Five exhibition. Winifred Nicholson was the chair of the society and Ben Nicholson and Christopher Wood were on the hanging committee. The Seven and Five Society was one of the leading forces in British avant-garde art at the time.

1931 Exhibition of twenty paintings at the Lucy Carrington Wertheim Gallery, London.

1933 *Cornish Port* reproduced in *Art Now* by Herbert Read (an influential survey of contemporary art).

1937 Adrian Stokes, *Colour and Form*, London, published: includes a discussion of Wallis's work.

1938 Herbert Read, L'Art Contemporain en Angleterre', *Cahiers d'Art*, no. 1–2: discussed Wallis in terms of contemporaries in British art. Included in *Unprofessional Painting*, Bensham Grove Settlement, Gateshead. Works by miners from the Ashington Group shown alongside Wallis and other "untrained" artists.

1940 Nicholson donated *Cornish Port* to the Museum of Modern Art, New York.

1941 Taken to the Madron Institute, the Penwith District Workhouse, by Mrs Peters, as Wallis could no longer look after himself.

1942 Died 29 August; buried at Barnoon Cemetery, 3 September.

1943 Articles by Ben Nicholson and Sven Berlin published in *Horizon*, 7, no. 37.

1949 One painting by Wallis included in the Penwith Society of Artists exhibition.

1949 Sven Berlin, *Alfred Wallis: Primitive*, London, published.

1965 Exhibition at the Waddington Gallery, London.

1967 Edwin Mullins, *Alfred Wallis: Cornish Primitive Painter*, London, published.

1968 *Alfred Wallis* exhibition at the Tate Gallery, London, and Arts Council Touring.

1985 Included in *St Ives 1939–1964*, exhibition at the Tate Gallery, London.

1987 *Alfred Wallis, Christopher Wood, Ben Nicholson*, exhibition at the Pier Arts Centre, Stromness (subsequently toured to Aberdeen and Cambridge).

1993 Opening of the Tate Gallery St Ives.

Alfred Wallis painting at 3 Back Road West, St Ives, ca. 1928. *Tate Gallery Archive, London*

1
Alfred Wallis
The Schooner and the Lighthouse
ca. 1925–28
oil and pencil on card
16.5 x 30.5 cm
Private collection

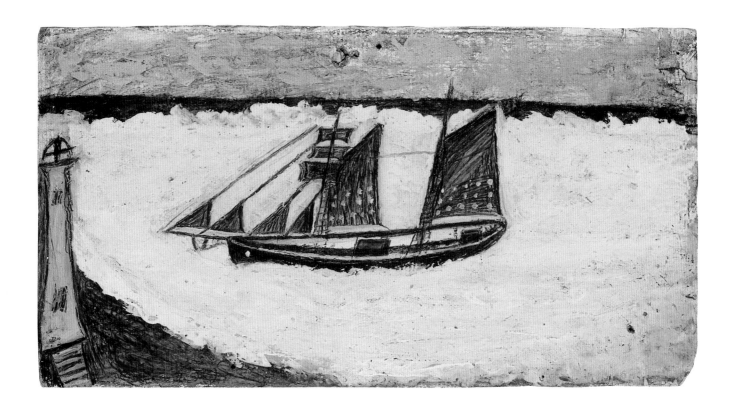

Alfred Wallis
The Blue Ship
ca. 1934
oil on board
43.8 x 55.9 cm
Tate Gallery. Presented by H.S. Ede, 1959

3
Alfred Wallis
Houses, St Ives
undated
oil on card
19.5 x 26.3 cm
W. Barns-Graham

4
Alfred Wallis
White Houses
ca. 1930–32
oil on card
14.9 x 23.2 cm
Kettle's Yard, University of Cambridge

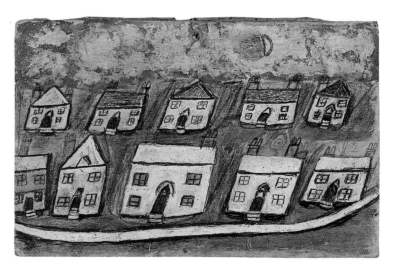

5
Alfred Wallis
Two Ships and Steamer Sailing Past a Port
ca. 1931
oil on card
37 x 52 cm
Kettle's Yard, University of Cambridge

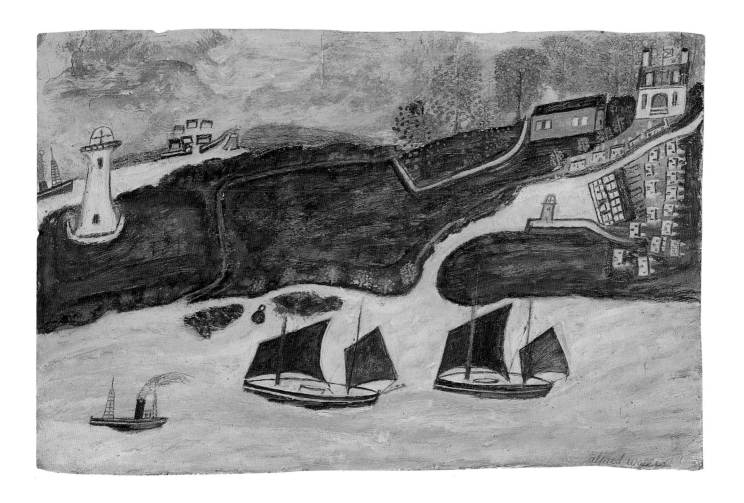

6
Alfred Wallis
The Hold House, port meor square island port meor Beach
ca. 1932
oil on card
30.5 x 38.5 cm
Tate Gallery

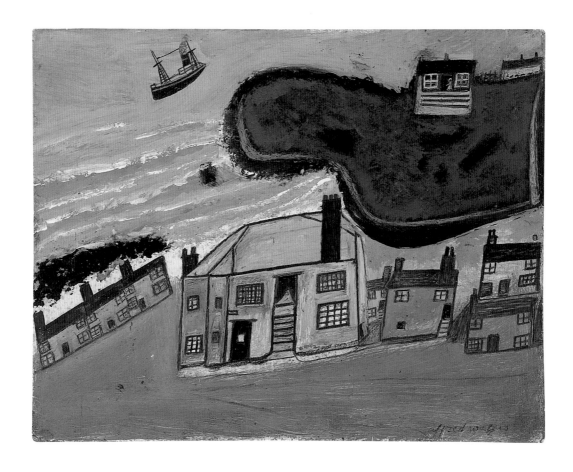

7
Alfred Wallis
This Sain Fishery that use to be
undated
oil and pencil on card
40.5 x 58 cm
Private collection

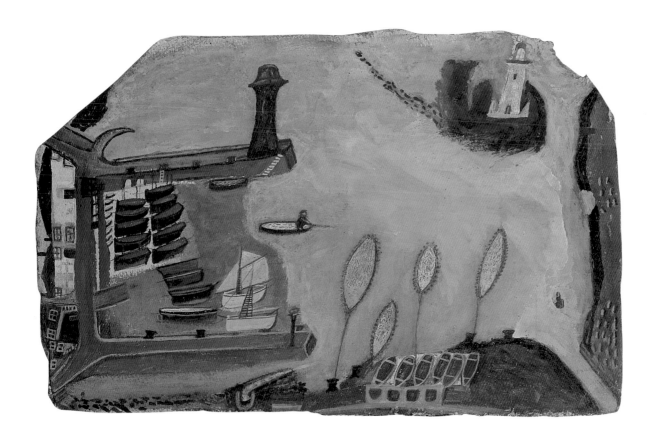

8
Alfred Wallis
St Ives Harbour, Hayle Bay and Godrevy and the Fishing Boats
ca. 1932–34
oil on card
64.1 x 45.7 cm
Private collection

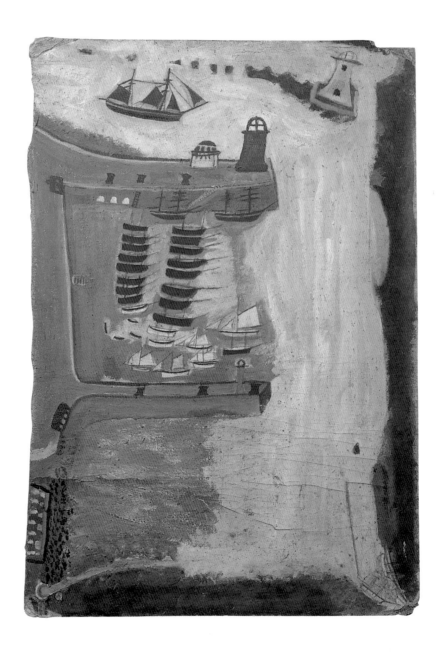

Alfred Wallis
There Was a Donkey
ca. 1930
oil on card
30.5 x 50 cm
Courtesy Crane Kalman Gallery Ltd, London

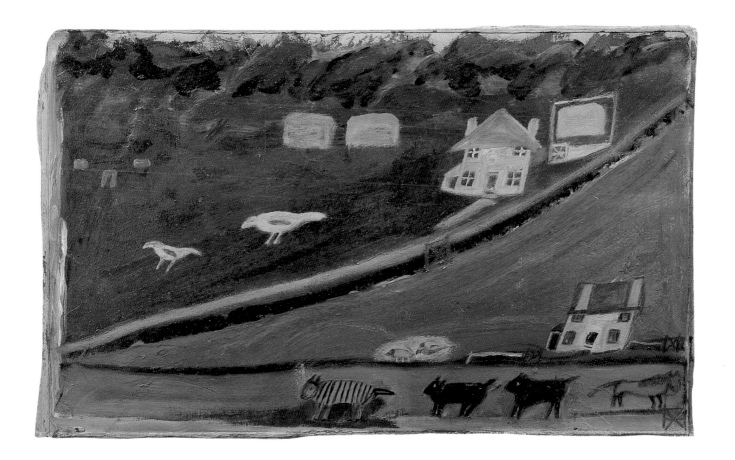

10
Alfred Wallis
The Walk
ca. 1938–40
oil on canvas
30.5 x 45.7 cm
Private collection

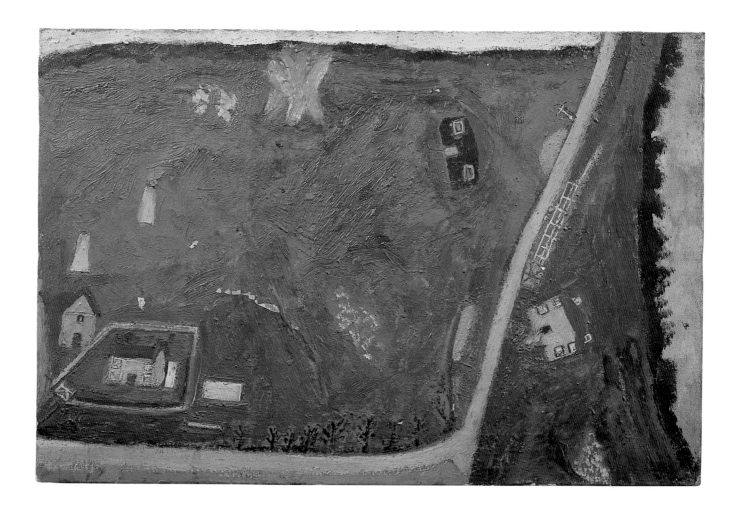

11
Alfred Wallis
Cottages in a Wood, St Ives
ca. 1935–37
oil on card
39.5 x 47.5 cm
Kettle's Yard, University of Cambridge

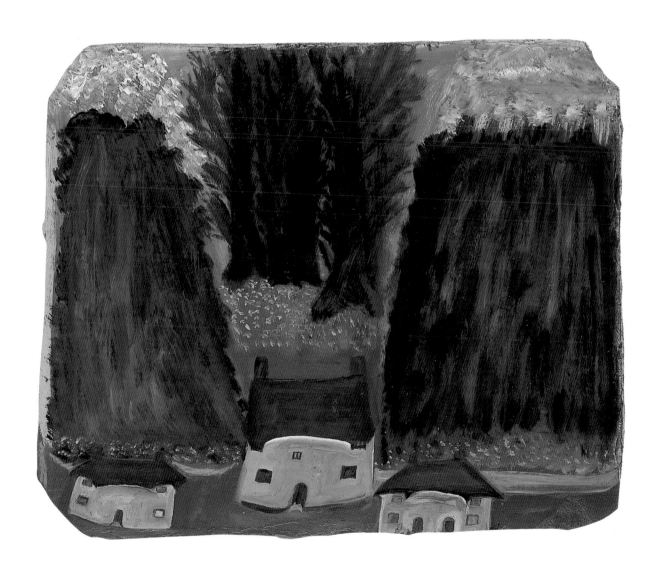

12
Alfred Wallis
The Forest
undated
oil and pencil on card
37.5 x 60 cm
Private collection

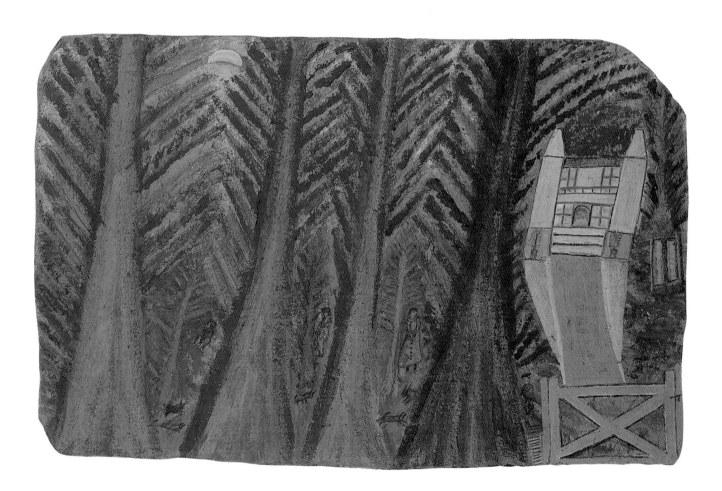

13
Alfred Wallis
Landscape with Two Large Trees and Houses
undated
oil on card
29.8 x 22.8 cm
Kettle's Yard, University of Cambridge

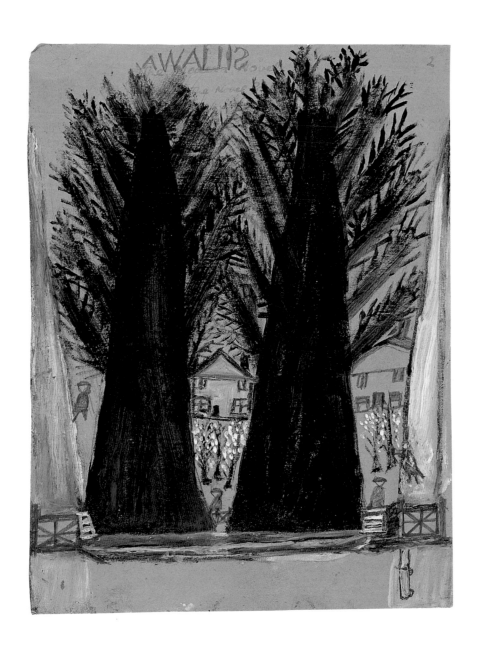

14
Alfred Wallis
Street of Houses and Trees
undated
oil on card
55 x 83 cm
Kettle's Yard, University of Cambridge

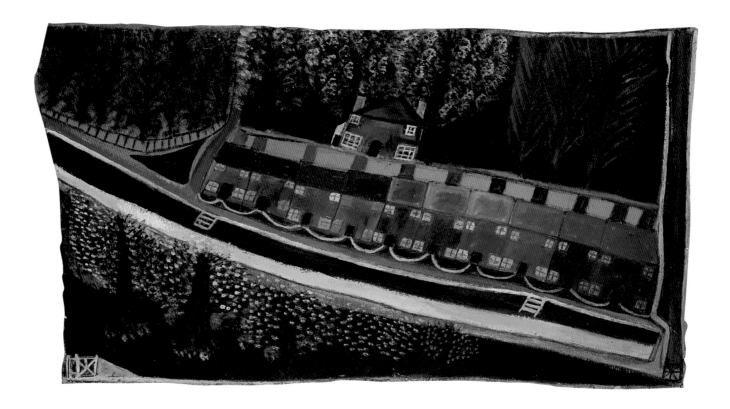

15
Alfred Wallis
Trees and Cottages
ca. 1935—37
oil on card
47.8 x 57.3 cm
Kettle's Yard, University of Cambridge

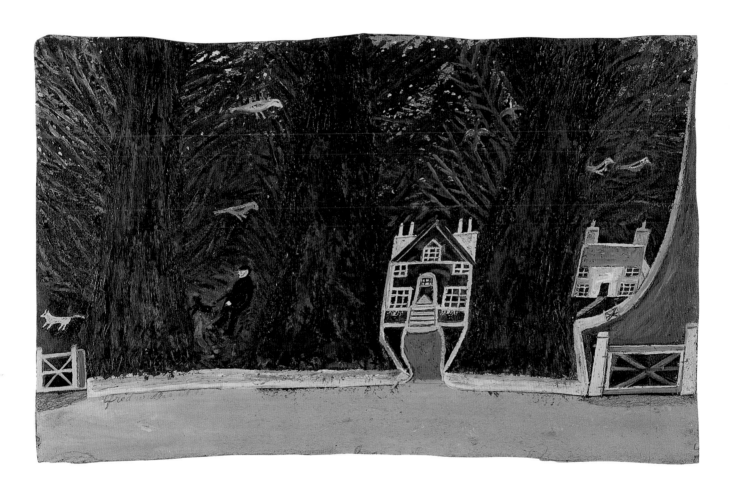

16
Alfred Wallis
Gateway
undated
oil and pencil on card
27.9 x 18.6 cm
Kettle's Yard, University of Cambridge

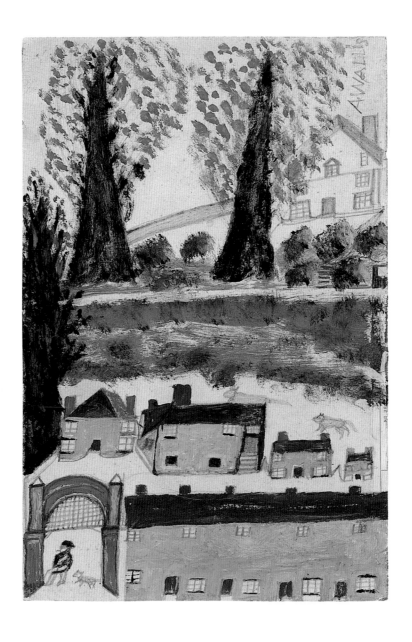

17
Alfred Wallis
Houses with Horse Rider
undated
oil and pencil on card
27.9 x 19 cm
Scott collection

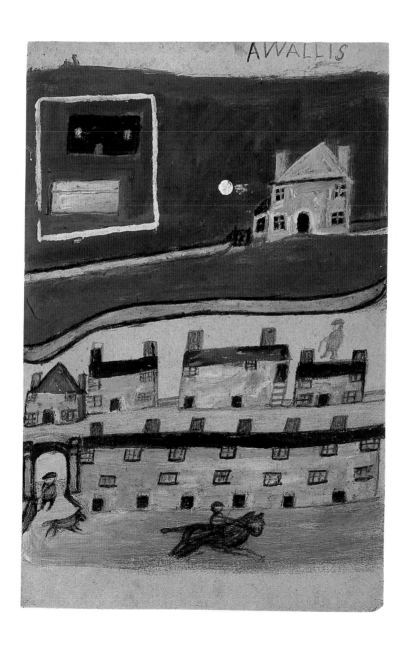

18
Alfred Wallis
Allegory with Three Figures and Two Dogs
ca. 1932–34
oil on card
25.4 x 17 cm
Kettle's Yard, University of Cambridge

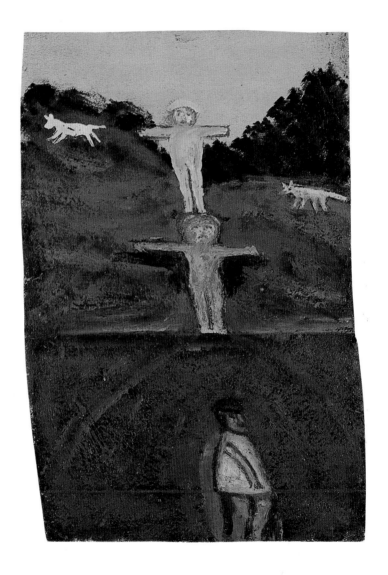

19
Alfred Wallis
Shy Lover
ca. 1930
oil on canvas mounted on board
37.5 x 45.5 cm
Courtesy Crane Kalman Gallery Ltd, London

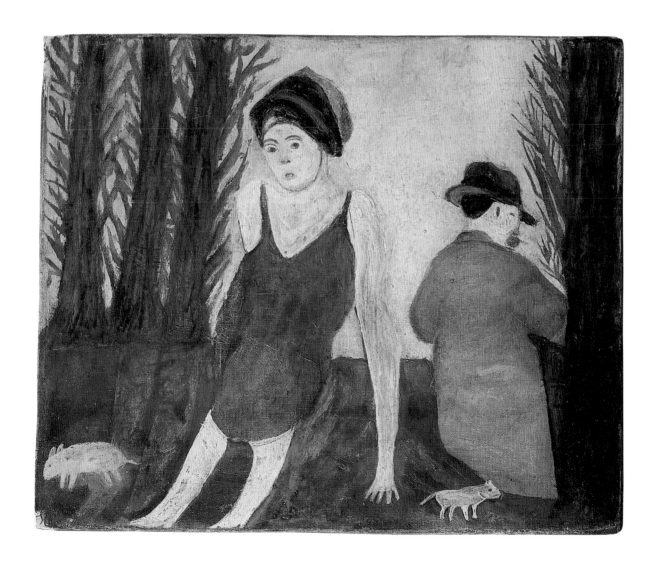

20
Alfred Wallis
Autumn
*ca.*1938–41
oil on card
28 x 48.3 cm
Private collection

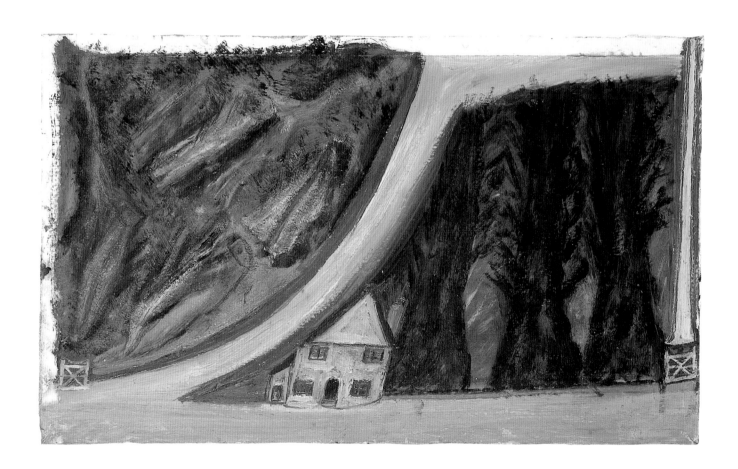

21
Alfred Wallis
Aqueduct
ca. 1938–41
oil on card
17.8 x 33 cm
Private collection

22
Alfred Wallis
Boats before a Great Bridge
ca. 1935–37
oil on card
36.7 x 39.2 cm
Kettle's Yard, University of Cambridge

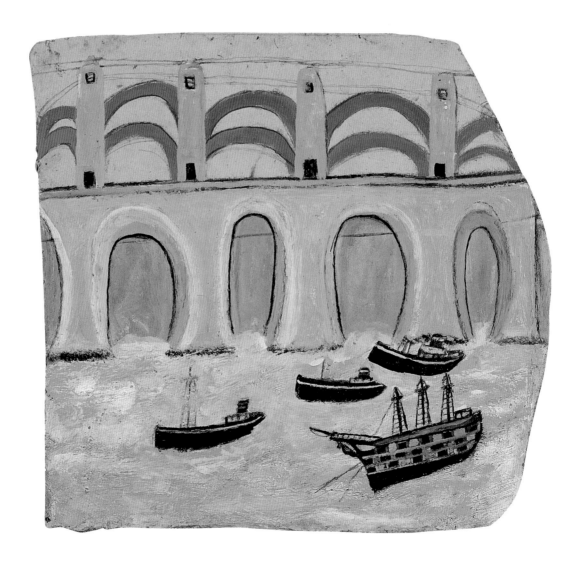

23
Alfred Wallis
Small Boat in a Rough Sea
ca. 1936
oil on card
26 x 29.5 cm
Kettle's Yard, University of Cambridge

24
Alfred Wallis
Ship in Rough Sea
ca. 1935–37
oil on cardboard
11.5 x 19.2 cm
Arts Council Collection, Hayward Gallery, London

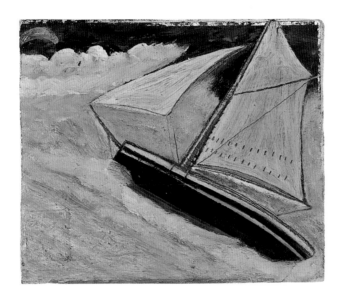

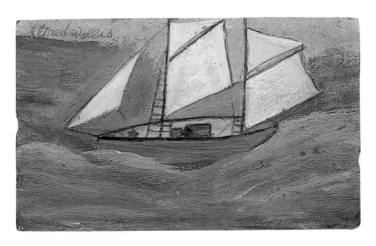

25
Alfred Wallis
Ship at Sea
ca. 1930
oil and pencil on card
27.5 x 39.5 cm
Courtesy Crane Kalman Gallery Ltd, London

26
Alfred Wallis
Three-Master on a Stormy Sea
ca. 1936–38
oil on card
17 x 36.9 cm
Kettle's Yard, University of Cambridge

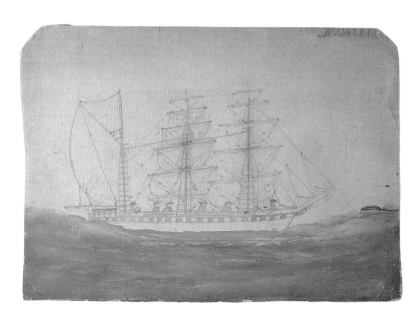

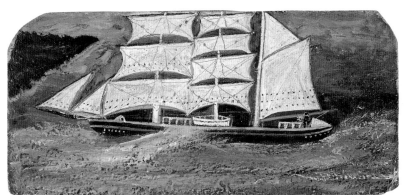

27
Alfred Wallis
Death Ship
undated
oil on card
19 x 30.5 cm
Glebe House and Gallery, Co. Donegal (The Derek Hill Collection)

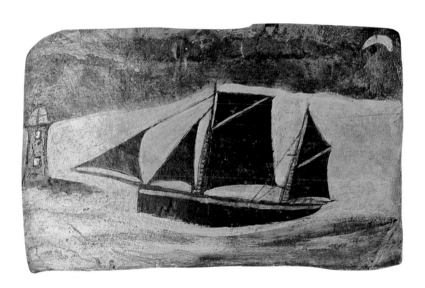

28
Alfred Wallis
Wreck of the Alba
ca. 1939
oil on wood
37.7 x 68.3 cm
Tate Gallery. Presented by the Tate Friends, St Ives, 1994

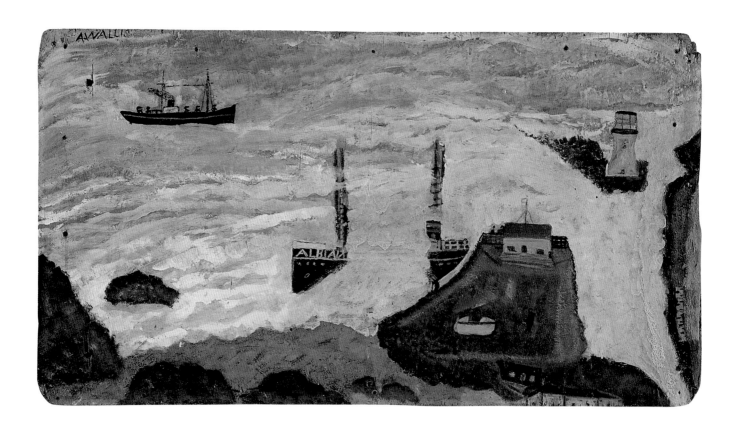

29
Alfred Wallis
The Wreck of the Alba and Lifeboat
ca. 1938
oil on card
27.3 x 33.8 cm
Kettle's Yard, University of Cambridge

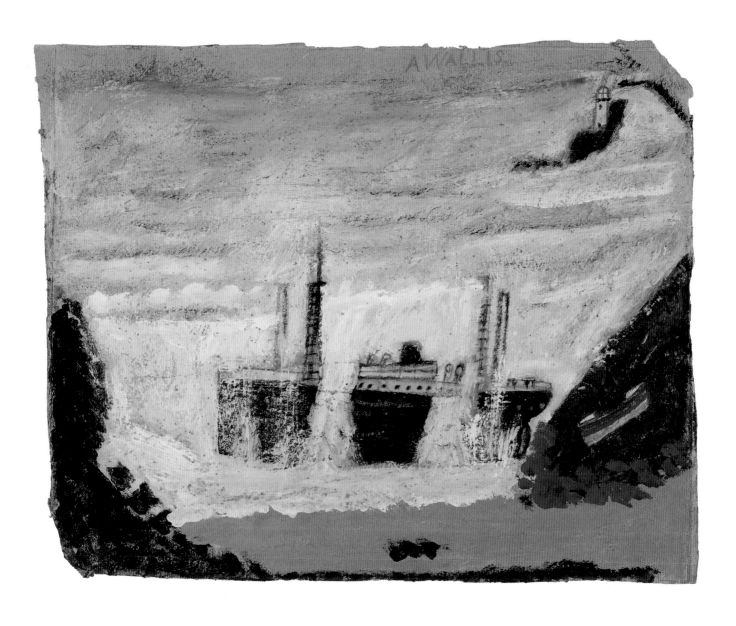

30
Alfred Wallis
Saltash Bridge
ca. 1938–40
oil on board
32.4. x 106.7 cm
Private collection

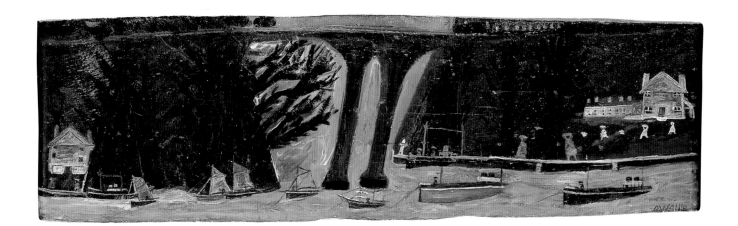

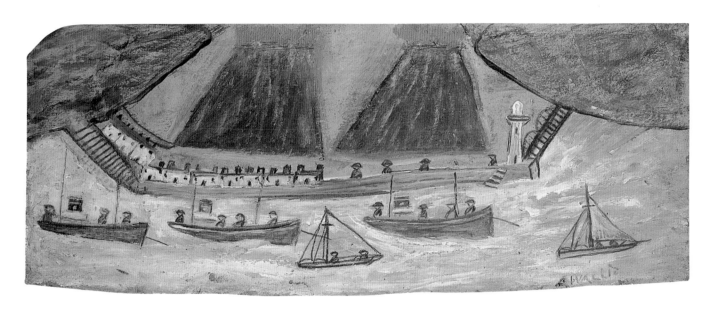

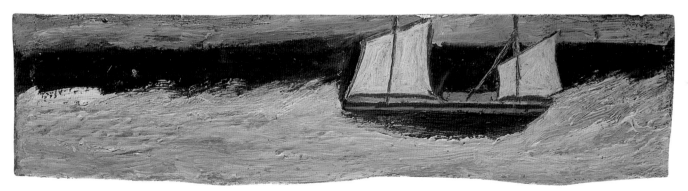

33
Alfred Wallis
Orange Ship with Five Fish
ca. 1941–42
crayon on paper
21.5 x 27.5 cm
Kettle's Yard, University of Cambridge

34
Alfred Wallis
Lion drawing book
ca. 1942
paperback sketchbook
21.5 x 28 cm
Private collection

35
Alfred Wallis
Roberson sketchbook
ca. 1940–41
hardcover, canvas-bound sketchbook
23.5 x 30 cm
Private collection

36
Alfred Wallis
Castle drawing book
ca. 1942
paperback sketchbook
each page 21.5 x 28 cm
Private collection

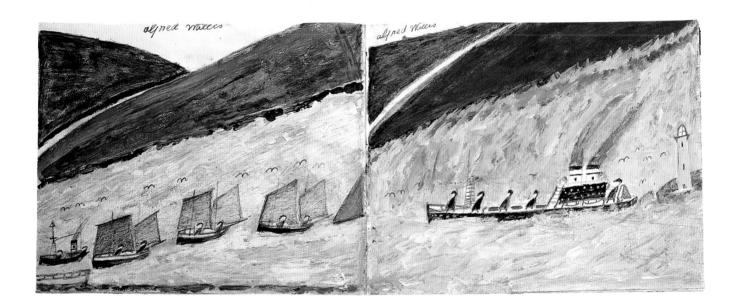

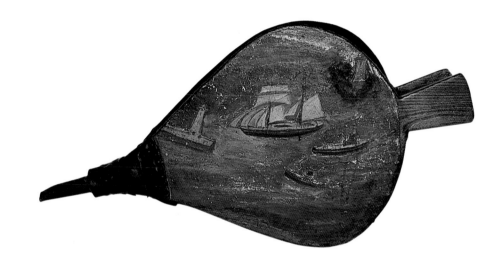

November 20
1828

Dear Sir i Received
your Order and i have sen
on Som more and i hope
They will please
i shall have To stop and
have a bit of outing for i am
getin of my food By Bein
in Two much
So i Think what i have
sent on will please
They That you sent Back
Rund Befor They was
Dry
They The one with Ruf
sea is st Ives Bay with
a fishing Boat Drove

Alfred Wallis

Letters

**Alfred Wallis to Ben Nicholson, 1928–34
Selected letters from the Tate Gallery
Archive**

November 20 1928

Dear Sir i Receved
your oder and i have sent
on som more and i hope
They will please
i shall have to stop and
have a bit of outing for i am
getin of my food By Being
in Two much
so i Think what i have
sent on will please
They That you sent Back
Rund Befor They was pay
The one with Ruf
sea is st Ives Bay with
fishing LuBoat Drove
a shore over By Hayle Bar
a Steam Drifter
so i hope you will get Them
all right so i must Close for The
Time hope you are all well
from your Truly friend
a Wallis respects To all

Nov 23 1928

Dear sir i receved
your letter with order
i was glad to see the pictures pleased i
hope
you are well
i think i will send on
what i have witch is
a Bit different
i have your book
which i Thank you
Came in while i was Ritin
Their is Nothing on The water
Than Beats a full Riged ship
so i must with respects
To all Your friend a wallis

January 28 1929

Mr Nicholson i Received
your order for 10 shillings
with thanks i have
had a verry Bad Cold i Thought
it was all over with me But
i am Thank full To Say i am
a little Better Thank god
i hope you are all keepin well
i am not as young as I used To Be
my Blood is weaker
i serpose you have a good
fon over my pictures because i never
learnt amd meerly out of the
head i think if I send on som
more To you you send som To The
other person and take out
The carrage
how is The little as he sailed
is boat yet i serpose you have
a pool with you ner by
try it i do
not think it ever
Been tried if he is like me
i was always for Boats
you must go yout and Try it
so i must clos with Best
Respects to all from your
Truly friend a wallis

april 8 1929

Sir i Receved your cheque
all Right i am glad your
plesed with som of the
pictures i serpose
you are pretty well serplied
for The Time so i hope your
pleased with what you
got i got two here the
last i have don and i am
going To send Them on
as a gift so you must not
send anything for them
so i Close with my
Best Respects oping your
all well from your True
friend alfred wallis

Jun 23 1929

Sir i Receved your
card and The Box
i have put on the front
what i could it is diffelt
To put any Thing on
and i have shaped out
a Boat one End and a vessel
on the other my paint
is don and gon thick
so The one Each End
you can do your self
i Do no Think i sahll
Trouble aBout Buying
Much mor pant i have
used many pounds of pant
i got som fin ones here
som where about 3
as they are dry i put
Them back and Covers
Them over i do not want
coming in and out i do not
git my living at it and
when i send on The next
lot i hope you will take
out 5 shillings for the
Box i thought you did
not want it as you took
away the little one when
Brought Back the Biger one
i did not thik it nesser
To put all around as long
as their was somthin in
The front when you scene
The next lot i hope you
Take out for the Box if you
do not i shall send on the
5 shillings
i Do not think i shall
trouble about buying
much more paint i am not
paid for thin i do put aBout
i only cone on an out as i see
anything i fancy i shall
like to take off if i saw
any passin on the water
and I had a tidey spy glass
Then i may Be aBle
so i must clos wishing
all well from your true
friend alfred wallis

Jun 6 1933

Mr Nicholson
i Receved your cheque all
Right with Thanks
glad you like them
i Thought it would Be a
Chainge as i have got ships
of all kinds here now
i have had one gentleman
and lady aBout month ago
They serlected a few i do not
shaw Them for sale Those
That have had from me is
Thous That can Draw Them
selves This is no place to
sell it si all Right to make
But not to sell inlan Towns
is the Best for sellin ships
i am verry fond of ships
of all kinds Rocks and Beaches
so their is only a few That Know
i do Them and That is They That
have them you as Red how
i am getting on all Right
Keepin farly well for my age
opin your all well and doing
plenty of work i serpos you
cannot com This way verry often
i serpos The little ones would
ender you would Be able to
serlect for your self
from your friend
alfred wallis
3 Back Road W St Ives C

april 23 1934

Dear Sir i receved
your letter with Thanks
i want moor outing
Than i have i keep in
two much i got a nice
lot here would siut
you and Mr Ede for
may and Summer season
But i would rather you
to com a see and serlect
for your selves as i am
only going To do only
one or Too in and out as it
will siut Com or send
you can have whats here
i dont offer any here for
sale nor show
your Truly friend
alfred wallis

From alfred wallis 3 Back Road St Ives C
May 5 1934

Der Sir i receved
your letter and cheque
with Thanks sory you never kept any mor i
wold
Rather that all would have
siuted you i hope you
will have a fin sumer
of Bisaness you have little ones to along
and
i will take money
so i hope you will keep
well keep so you will be
able to do your work
so i must close wishin
well from your true friend
alfred wallis

undated fragment

i shall only do one in
and out if i see any
Thing new that strik my
atension i Tell you what i am
a Bible Keeper it is Red
3 hundreds sixty times
a year By me and That is
averyons Duity

Alfred Wallis to Jim Ede, 1929–39
Selected letters from the Kettle's Yard
Archive

april 24 1929
alfred wallis back Road W St Ives

Dear Sir

i Received your letter all Right and that
the other gentleman
is gon away For a wile
so it is no good Ritin him
ontill he coms hom again
you also menttened
about your Brother law
i got som paintins here
when they are dry
i should think i have
a scor weather they would
suit him i do not know
i like them my self
i think they are pretty
fair sort
sir you mentined aBout
The i thought it not
nessery to paint it all
around so i never don it
did you geve me any
Thing when you ad
The Box for it and i
did not pay you Back
if so send and leave
me know and i will
send it on i think
the price was 2 shillin
a woman cam in one
day and Bought som
pictures and i sold
it for 2 shillings
if you paid me at The
Time and i never paid
you Back Tell me and
i will send it on
i cannot say

From alfred wallis st ives
Feb 12 1934

sir i have sent on a parcle
as They are Dray i think They
will do as They are what used to
Be most all i do is what use to
Be in ships and Boats what you
phrape what you will never see
any more i like sailin creft
Best for looks
so i must Clos wishing you
good speed From your friend
alfred wallis

on a card

most i do is what used to Be

Sep 14 1934

Dear Sir Received your
letter chequ all right
with thanks
verry glad you Receved
Them all Right and That you
are pleas i should like for
you to com and serlect for
your self any tim
opin you are well and
Mr Nicholls family
from your true friend
alfred wallis No 3 Back
Road West St Ives

alfred wallis Dec 19 1934
3 Back Road West

Dear Sir i Receved your
letter and oader with thanks
i have a few here But
They are Two large for
The post if their was any
one Coming Down you Knew
and would Take Them
To you They could have
Them
i Rember a man with
Mr Nichollson he was a stranger to me i
never
saw him Befor
i clos wishin you all
a merry Christmas and a new year when
coms i hope things
will alter for the Bettr
Both for Trade and Trad
your True friend a wallis

Jan 8 1935

Dear Sir i Receved
your letter i Thought i would
give The Doctors home
That lot of pictures
out of charity and you
Bein in london you
would know Best wher
To Drop it to
you must Take it in
faith i am Doing it
To help for it is all
needed when you git
Them i hope they will
pleas i Do it to help
and give Mrs Elles somthin
for Trouble for fething them
out of it
Yours Truly a wallis

Jan 1935

Sir i Receved your letter
i do not think i have mad
a merstak i saw a little Boy
an The Paper looking well fed
and he has a large family
To keep i thought that if he had
The worth givem it would
Be all help i ham poor my
self a penchener of old age
the paintins do Com in To
By Clothin or any thing in
that way needfull
it is not the first tim i have
helpt such causes i think
i think it aught to Be put
That way mor Than it is
not in simenes and theaters Sunday
Their is Two
much money thrown away
when Their is Better it can be put in
so i must close from your
friend alfred wallis
3 Back Road W
St Ives

3 Back Road w
St Ives

Feb 26 1935

Dear Sir glad To Receve your
letter That your a little Better
i am also glad for what you have
Don for The Home quit satasfied
Every little is help Their is a lot
of money thron away That Could
do more good Than lots of people puts
in i hope others That got a lot will so a
little and not Through money away in
what is no good To Body not soal
i must with love to all
from your friend alfred wallis

Ap 6 1935

Dear sir i Receved
your letter with thanks
and also The pantins wich you
Did not want
What i do mosley is what
use to Bee out if my own
memery what we may never
see again as Thing are altered
all To gether Ther is nothin
what ever do not look like
what it was sence i can Rember
if i live Till The 8 of august
next i shall be 78 years old
i was Born in Devenport
Born on the day of the fall of
Serveserpool Rushan War
so i clos from your
friend alfred wallis

July 24 1935

Dear Mr Ede
i received your letter and oaders
and i am glad your pleased
and i am also please with want you sent
their is only 3 or 4 that haves all i do
i do not offer non for sale nor do i shaw
them
all i do is houtht of my own head
and past tim you mentined
about sendin on a Box i do not know
what to pot on it as i have nothin
to look at
i must com to a Close
wishin you well and good luck
from your true friend
alfred wallis

3 Back Road W St Ives Cornwall

Dec 12 1935

sir i receved chequics
all Right with Thanks
i do not shaw any pantins
and Their is only 3 or 4 do
have all i do so i Cannot hart verry
much other people very much
so i must wishin you all a merry
Christmas
from your friend a wallis

april 1 1936

Dear Sir i Receved you letter
and checqu all Right with Thanks
glad you Receved The paintins
The most you get us what use to Be
all i do is Hout of my mery
i do not go out any where To Draw
and i show any nor offer any for sale
Their is only 3 or 4 That have had all
i have don i got som large ones
But They will not go By Post
The one with the Crab pots and fish
is serpos to Be at the Bottom
i must clos wishin you good speed
opin your well from your
True friend alfred wallis

July 23 1936

Dear Mr Ede
i Received your card
i Received The parcle
i have not opened it
yet i thought it all
i do not open Them
ontill i want To alter
Them yours Truly
alfred wallis

Oct 23 1936

Dear Sir
i have sent
on a picture The Whater is
Penzanc Bay and the Other
Consols Mine Too Stacks
and The old Engin House
in The Bottom and The Road to
Zennor St Just Lands End

November 4 1936

Mr Ede
i receved your letter
and the Returned parsel
with Thanks Mr Ede
i never see any Thing
i send you now it is
what i have seen Before
i am self taught so you
cannot me like Thouse
That have Been Taught
Both in school and paint
i have had to learn my
self i never go out to paint
nor i never show them
from your friend
alfred wallis
3 Back Road West st Ives

3 Back Road West St Ives
Mar 1937

Mr Ede i receved
your letter and chuques
with Thanks glad you
like som i Think in
Those in Thouse ships
would take Befor Houses
anyhow you know Best
now i will Tell you my
age i was Born august
8 1855 The fall of
servasterpool we was
To war with Russia
i was Born at North Coroner
Devenport
so i must clos
wishin you well from your friend
alfred wallis

March 23 1937

mr Ede i Receved
your letter it is a good Bit sence i
have hied from london
i got som paintins They are not
proply dry i will send on som
when They are fit
you mentioned aBout my Ellenes
i was verry porley and i was not
out for 3 days and i was knocked
Down with a moter Car Coming Behind me
and it shook me insid and out
i Cannot stand That knockin about
i wonder i was not killed
i must clos wishin you well
from your friend alfred wallis
3 Back Road W
st Ives

april 27 1937

Dear Mr Ede
receved your letter
and chucks all Right
glad your pleased
i leave all with you you know
how to manage Better than I do
i always like to know
That the Parcle is received
all Right The Bigone is
from St Ives Down to lands End
and long ships 3 mile off
from The lands End
i must clos for the Time
wishing you well
from your friend
alfred wallis
3 Back Road W

May 25 1937

Dear Mr Ede
i Receved your letter
and chuke with Thanks
you asked when i
painted it sence you had
The last lot sent you
Their was somthin
i did not like and
and i wiped it out
and put it on it what
you see so i must clos
wishin you well
from your friend
alfred wallis

april 8 1938

Dear Mr Ede
i Thought i was forgot
i have sold only one
lot of paints sence you
had The last i have not
Been very well i was Run
over By a Motercar In The
street That have shook
me i Canot Stand That
sort of work at my age
80 years of age 8 next
august Born in 1855
Devenport Mr Ede i have
a few of The lates Don
you can have when you
com Back all Being well
my adress is
alfred wallis
3 Back Road W
St Ives Cornwall
England

July 1927 1938

Dear Mr Ede i receved
your letter i see By it you have arrived
home
i am thinking of
givin up The paints
all To gether i have nothin
But Percuition and
gelecy and if you can
Com Down for a hour or 2
you Can Take Them with
you and give what They
are worf To you afterwards
These Drawers and shopes
are all gelles of me send
or com you can have
Them all There is a lot of Them
and at my age is is mor
Than i can stand i may do
one now an Then when i
Feel able send Down
anyone that is Coming
This way or Com nothin
But percuitin i want to live
To The Schpter not mallace
you Can Com or Send
and Take Them away
and pay what ther worth
afterwards
so i clos wishin you
all well From your Friend
alfred wallis 3 Back Road W
St Ives
you can have The lot By comin
or sandin

July 30 1938

Mr Ede
i have about 30 or 40
pantins They must
go By Train somone
fetch Them if Their
was any coming from
your place They Could
Call and Take Them
away i want Them
cleard out i do not
know how soon i shall
have To moove The house
wants a great Repare
i think Their They are so
good if not Better i haved
don They are Two many
for To send By Post
i do not make any shaw
of Them nor offer Them for sale

aug 14 1938

Mr Ede i receved
your letter and oader
i want what you
what you do not
want to Leave som
one Elce have i do not
want any sent Back
i got a few here i can
send By post som Time
your truly alfred wallis

so i leave it to you which is The
Best They will fill
your room up
so i leave it up to you
wich is The Best
from your Truly
friend a wallis

July 6 1939

Dear Mr Ede
i received your letter
very glad To see By it
your well That is for
my self som Days farly
well and som not much
it canot Be much other
at my age 80 four
8 next august you
menthened aBout The
pictures i have not Been
But verry little latly
only one or Two now and
Then gave up all together
very near
comin Two old now
i got a few don just
what coms in my mind
i do not know things
Been like sence The war
Every Thing seems To Be
in a on settled stated
natain against natain
it seems all over The
World Schrisper The Big
War is The Comencent of
Trouble Their as Been
nothin Ever sence
i serpose it is Just The sam
with you i hop it
will soon com To a proper
settled peace
so i must clos wishin
you well and a fin
passage when you
leave To Com hom
from your friend
alfred wallis
3 Back Road w
st ives Cornwall

James Dixon
Biography and Selected Exhibitions

1887	Born 2 June on Tory Island, Co. Donegal. Apart from an occasional visit to the mainland and one short period in the west of Ireland as a fishing instructor, Dixon spent most of his life on Tory Island, devoted mainly to fishing and small-scale farming.
1950	Constructed 'Ship in a glass case' (no. 72), a model of Wallace Clark's yacht the *Wild Goose*.
***ca.* 1952**	Painted *Mr Clark Passing Tormore in his Yacht* (no. 38). Dixon gave this to Wallace Clark when the latter visited Tory Island. Wallace Clark recounts receiving several works during this period.
Early 1950s	Derek Hill first visited Tory Island, subsequently becoming a regular visitor and befriending several of its inhabitants.
1956–58	Dixon's first encounter with the English artist Derek Hill, who was working on a large landscape entitled *West End Village*. In what became a well-documented account, Dixon, on observing Hill's rendition, remarked "I could do better". Consequently, Hill's encouragement was accepted in the form of a gift of paper (Dixon preferred paper to canvas), although the offer of standard brushes was declined as Dixon favoured the use of donkey-hair brushes, a factor that added to the painterly quality of his work. (Exact dates for this initial encounter vary: Derek Hill records it as being 1956/57 (see *Irish Arts Review*, 1993), while a date of 1960 has been suggested elsewhere.)
***ca.* 1958**	Dixon painted *West End Village, Tory* (no. 39), the first painting he produced after his initial meeting Derek Hill. Hill later purchased the work, now in the Glebe Gallery collection, Co. Donegal.
Early 1960s	John Berger visited Tory Island with Derek Hill and met James Dixon.
1966	First one-person exhibition, containing twenty-one paintings, at The New Gallery, Belfast. This was followed by another exhibition, at the Portal Gallery, London, in November 1966.
1967	Exhibitions at the Dawson Gallery, Dublin, and the Autodidakt Gallery, Vienna.
1968	Exhibition at the Portal Gallery, London. Between 1968 and 1973 works by Dixon are documented as having appeared in auctions held by Sotheby's. Exhibited at The New Gallery, Belfast, alongside other painters, including Johnny Dixon (his brother), James Rodgers and Patsy Dan Rodgers.
1970	Died on Tory Island.
1971	Included in *Irish Primitive Painters* exhibition at Queen's University, Belfast, and *Elements of Landscape* at the Municipal Gallery of Modern Art, Dublin.
1972	Exhibition at Grange House, Ballyragget, Co. Kilkenny, of works by James and Johnny Dixon, James Rodgers and Patsy Dan Rodgers.
1980	Included in *Irish Art 1943–1973*, Cork Rosc, an international contemporary art exhibition held intermittently (approximately every four years).
1983	Included in *Tory Island Painters*, an Arts Council Touring exhibition.
1990	*James Dixon: A Retrospective Exhibition* at the Glebe Gallery, Co. Donegal, and the Boole Library, University College Cork. Included in *Contemporary Artists from Ireland* at Austin Desmond Fine Art, London. Other artists exhibited included Camille Souter and Harry Kernoff.
1993	Included in *Driven to Create: Anthony Petullo Collection of Self-Taught and Outsider Art*, a touring exhibition organized by the Museum of American Folk Art, New York.
1997	Included in *Aspects of Modern British Painting* at Austin Desmond Fine Art, London.

James Dixon at work, Tory Island, 1964. *Photograph by W.M. Patterson*

38

James Dixon

Mr Clark Passing Tormore Tory Island In his yacht with
a Whole Gale of S.W. Wind & rain With Jill and Others
on Board after Leaving Greenport with Daylight about
the year 1952

ca. 1952

household paint on brown paper

63 x 81 cm

Collection of Wallace Clark

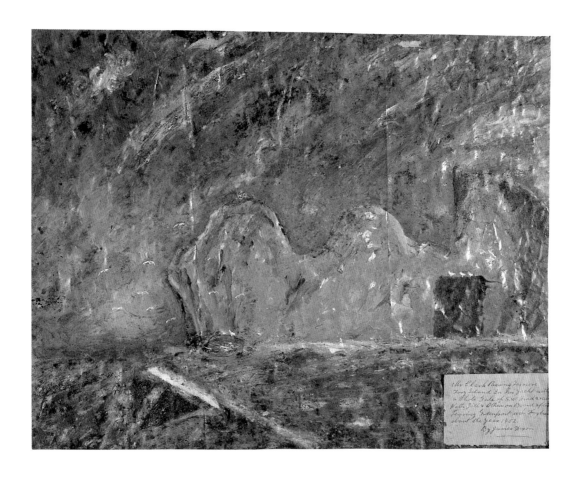

39
James Dixon
West End Village, Tory
ca. 1958 (uninscribed)
oil on board
96 x 66 cm
Glebe House and Gallery, Co. Donegal (The Derek Hill Collection)

40
James Dixon
Ellie Ward
1962
oil on paper
38 x 28 cm
Private collection

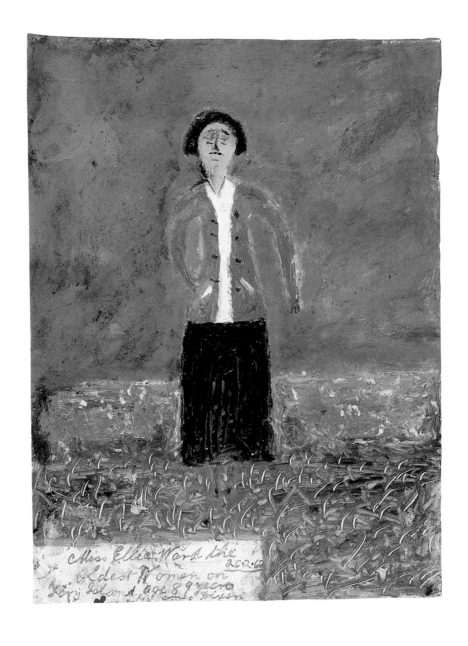

41
James Dixon
Miss Jill Clarke
1963
oil on paper
38.5 x 27 cm
Glebe House and Gallery, Co. Donegal (The Derek Hill Collection)

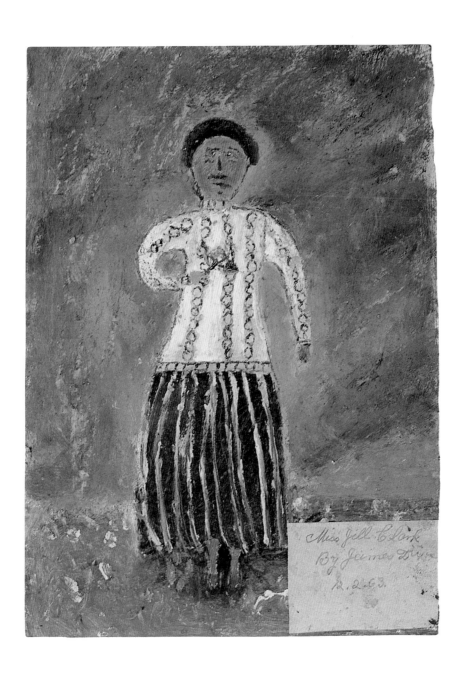

42
James Dixon
The Archangel Gabriel
1963
oil on paper
75 x 55.8 cm
Hugh Strain

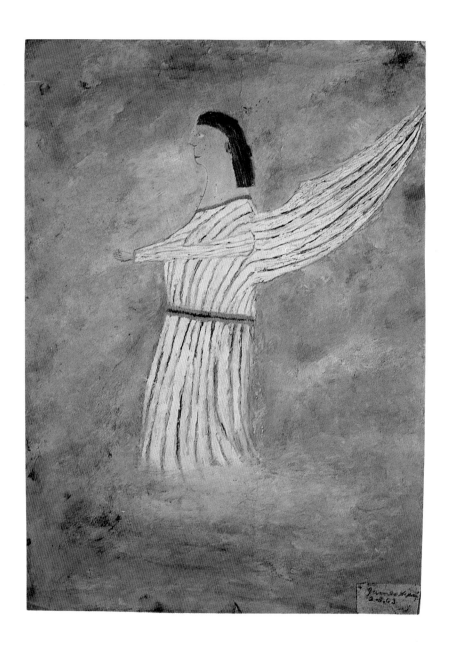

43
James Dixon
Ave Maria
1969
oil on paper
55.8 x 35 cm
Hugh Strain

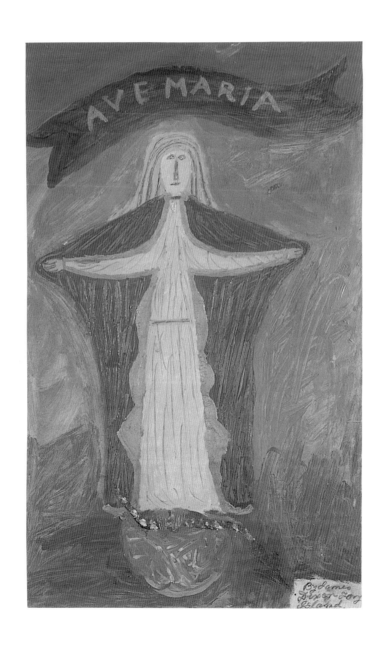

44
James Dixon
Self Portrait
1963
oil on paper
54.6 x 75 cm
Private collection

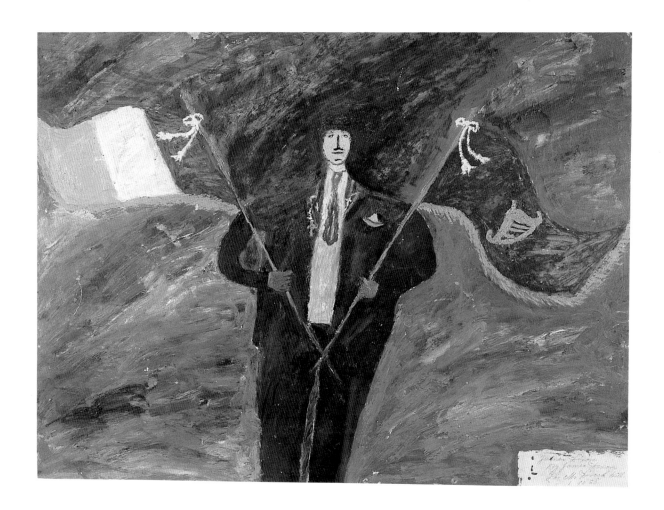

45
James Dixon
Mr Hill by James Dixon
1966
oil on paper
56 x 36.2 cm
Private collection

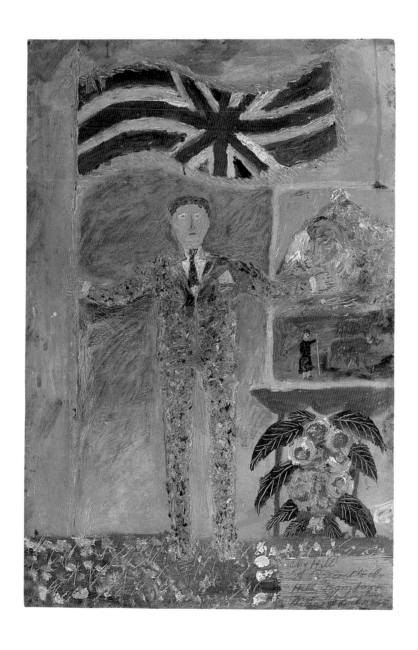

46
James Dixon
Tory Island East End
ca. 1962 (uninscribed)
oil on paper
107 x 293 cm
Private collection

47
James Dixon
Tory Island West End
1962
oil on paper
98 x 366 cm
Private collection

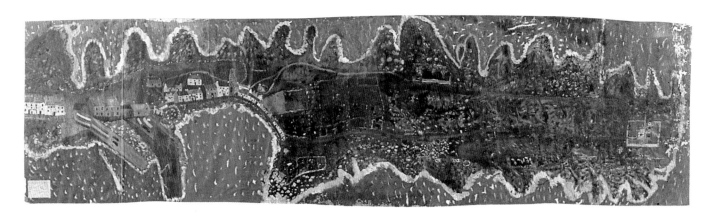

48
James Dixon
West End Village Tory Island in a Storm
undated
oil on paper
58.5 x 76 cm
Collection of Maureen Dullaghan

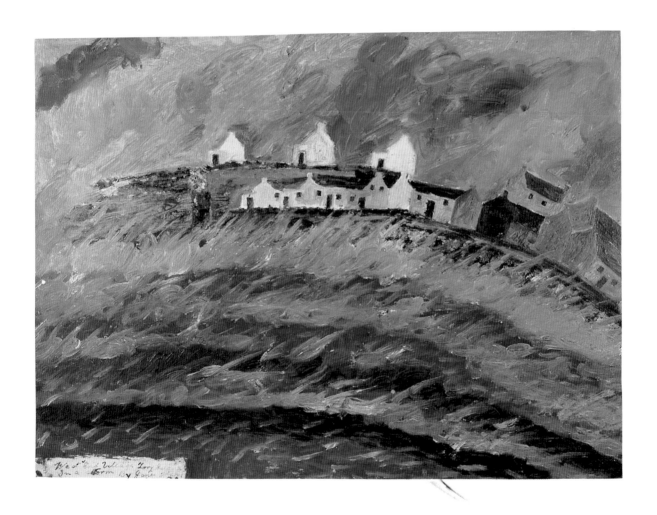

49

James Dixon

Mary Driving Cattle Home Across the Sands of Dee

1964

oil on paper

57 x 71 cm

The Collection of the Arts Council/An Chomhairle Ealaíon

50

James Dixon

The Fair Holm on the Rocks

1966

oil on paper

48.3 x 65.4 cm

Private collection

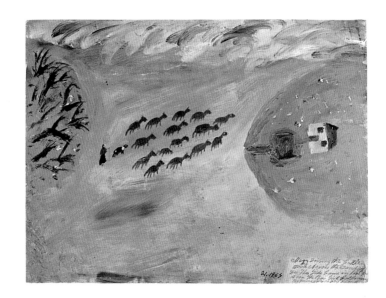

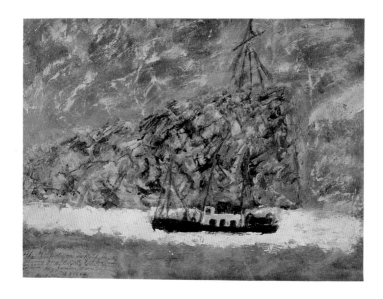

51
James Dixon
British Minesweepers at Work Between Tory Island and the Mainland
1965
oil on paper on board
56.1 x 75.9 cm
National Museums and Galleries of Northern Ireland

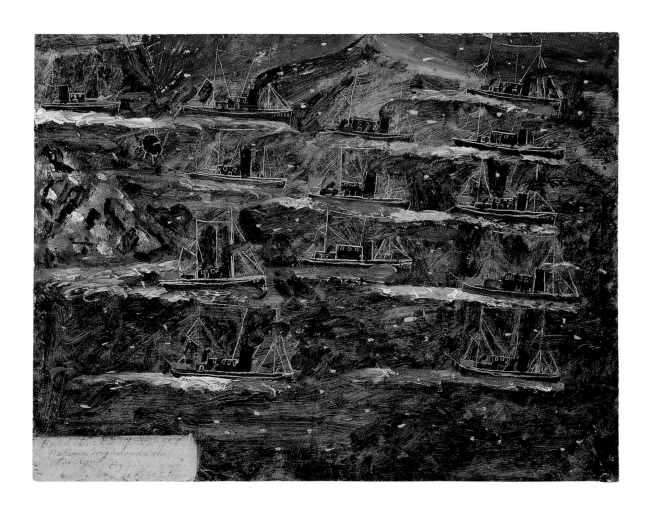

52
James Dixon
West End Village Tory Island, About 300 Years Ago
1964
oil on canvas paper
55.8 x 76.3 cm
Private collection

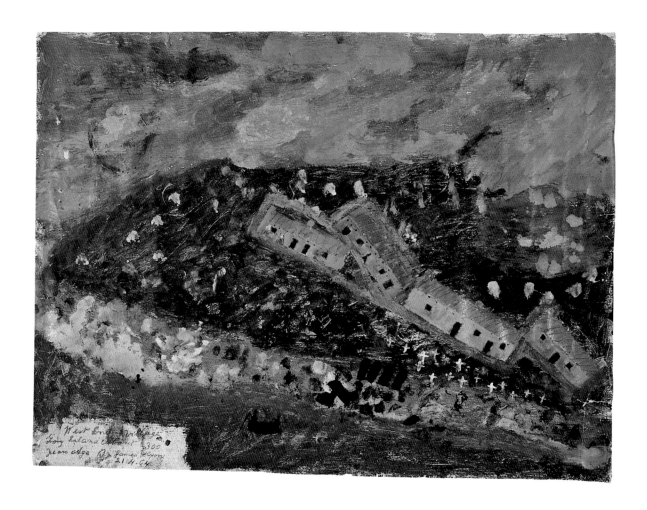

53
James Dixon
A Picture in St Colmcille's Hall
ca. 1964
oil on paper
54.6 x 75 cm
Private collection

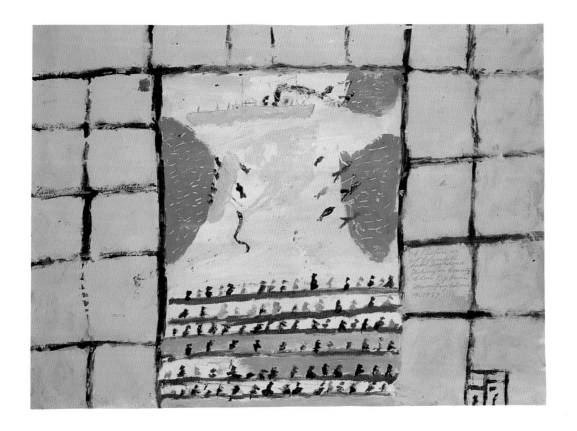

54
James Dixon
Mr William Rogers Plowing in Dixon Farm Tory Island
The First Tractor That Ever Came to Tory Island
1967
oil on paper on board
57.2 x 76 cm
National Museums and Galleries of Northern Ireland

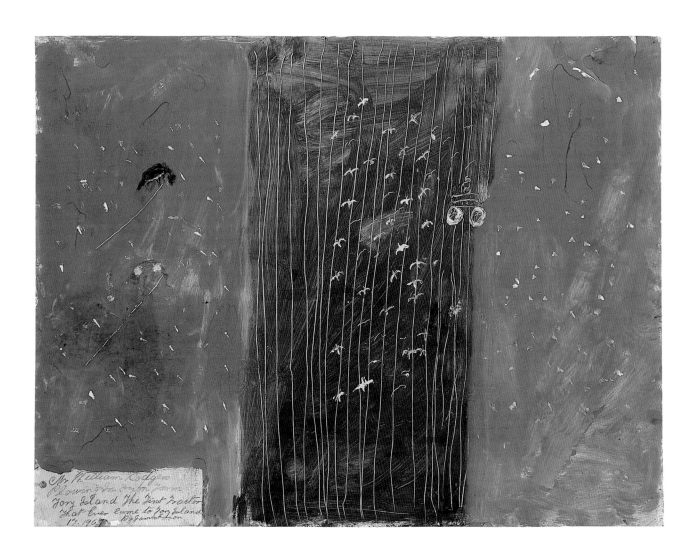

55
James Dixon
Schooners Passing Tory Island
1967
oil on paper
56 x 76 cm
Kettle's Yard, University of Cambridge

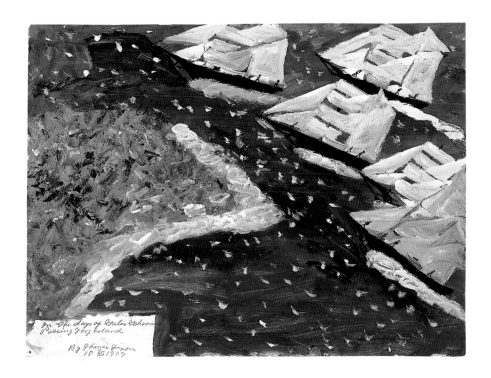

56
James Dixon
The Sinking of the Titanic
1967
oil on paper
38 x 54 cm
Kettle's Yard, University of Cambridge

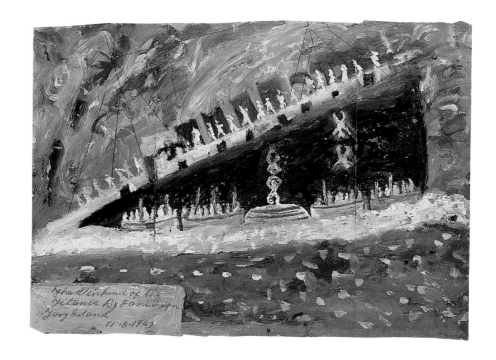

James Dixon
Digging Potatoes in Dixon's Farm
1967
oil on paper
56 x 75.5 cm
Kettle's Yard, University of Cambridge

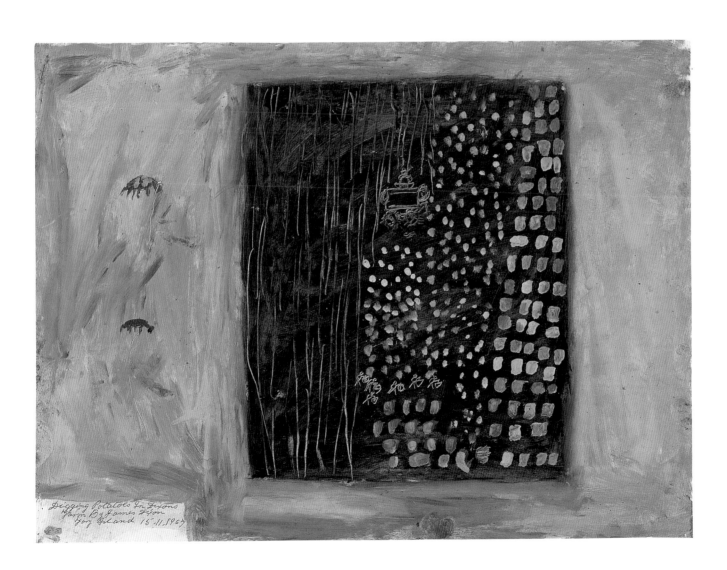

58
James Dixon
Fishing on the Pier
1967
oil on paper
62 x 82.5 cm
Kettle's Yard, University of Cambridge

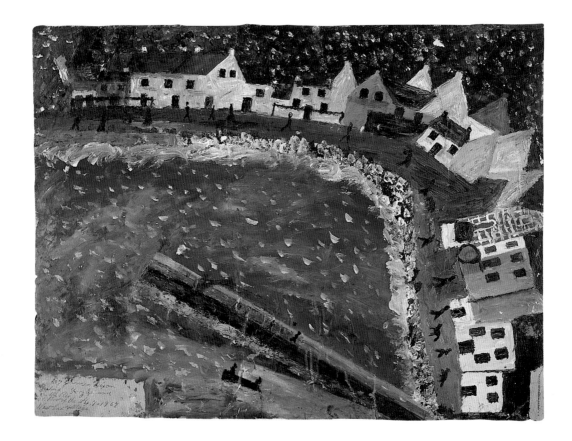

59
James Dixon
The First Time the Helicopter Came
1967
oil on paper
55.5 x 76 cm
Kettle's Yard, University of Cambridge

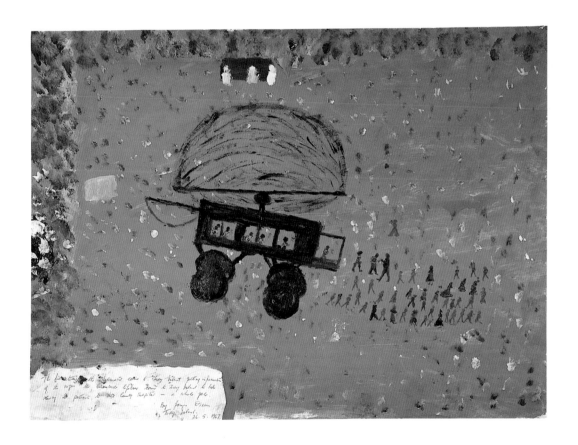

60
James Dixon
Ave Maria – The First Motor Boat on Tory
1968
oil on paper
57.2 x 76 cm
Mr W.M. Patterson

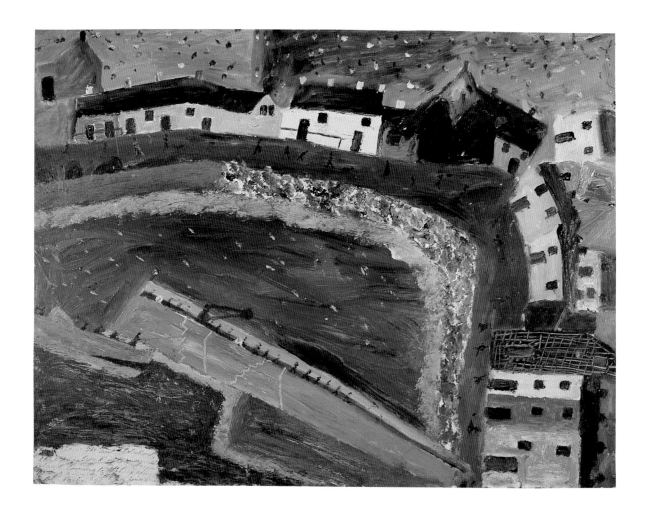

61
James Dixon
HMS Wasp
undated
oil on paper
56 x 76 cm
Glebe House and Gallery, Co. Donegal (The Derek Hill Collection)

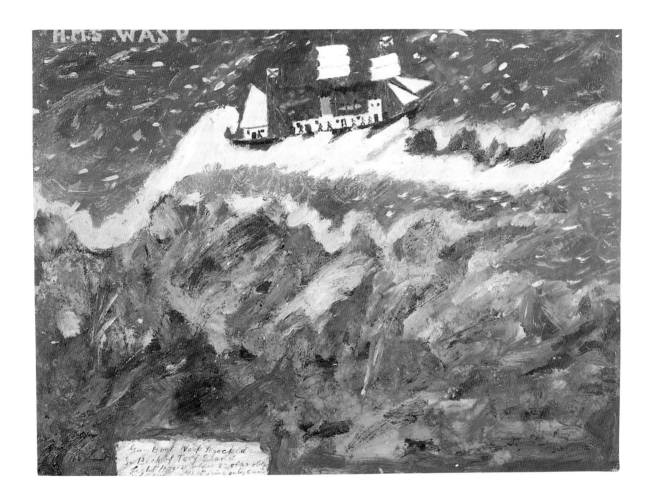

62
James Dixon
The Gypsy Moth Rounding Cape Horn
1968
oil on paper
54.6 x 75 cm
Private collection

63
James Dixon
Grey Lag Geese Resting on the West End Lake, Tory Island
1969
oil on paper
56 x 76 cm
Private collection

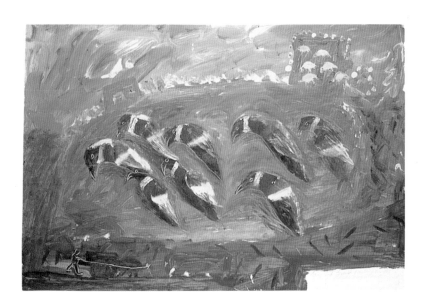

64
James Dixon
Green Hawk
1969
oil on paper
Private collection

65
James Dixon
The Ram's Hollow
1969
oil on paper
54.6 x 38.7 cm
Private collection

66
James Dixon
The Queen Coming Home on the Royal Yacht Britannia
1969
oil on paper
56 x 76 cm
Matthew J.F. Bailey

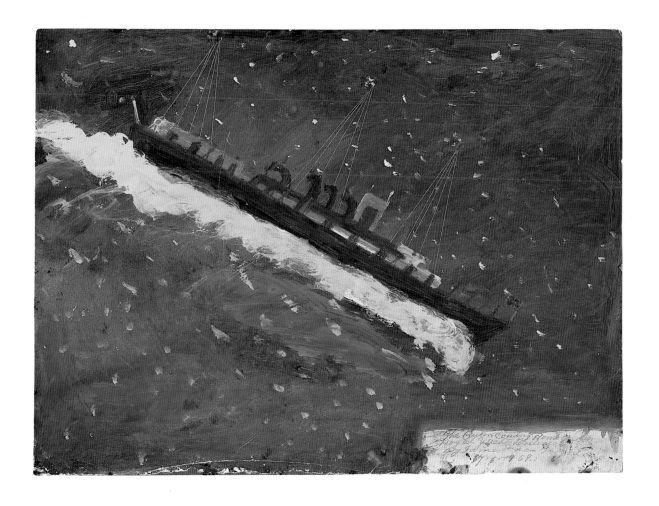

67
James Dixon
Cutty Sark
1966
oil on paper
56 x 76 cm
Private collection

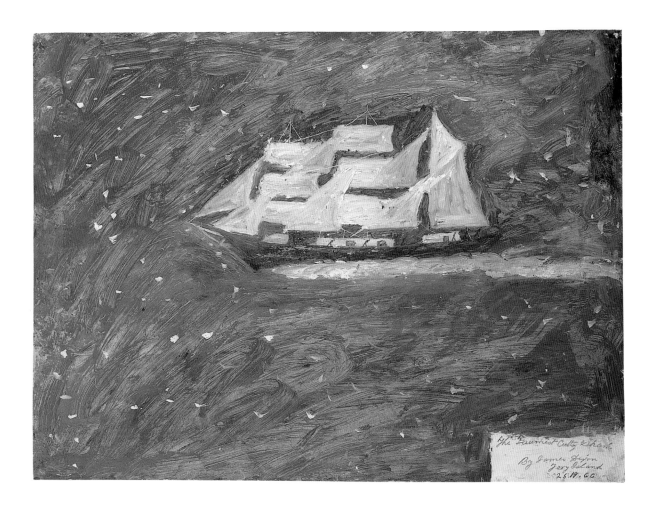

68
James Dixon
Scotch Lugger Passing Tormore in the Evening
1945
oil on board
54 x 75 cm
Private collection

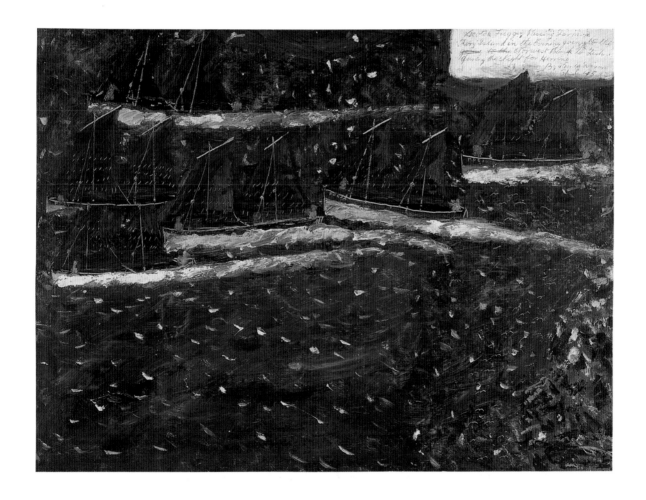

69
James Dixon
The Last Rose of Summer
1969
oil on paper
54.6 x 24.7 cm
Private collection

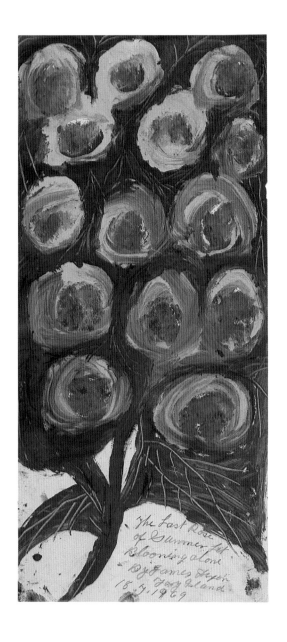

James Dixon
Cutting Corn (The Last Picture)
ca. 1970 (uninscribed)
oil on paper
56 x 75.2 cm
Private collection

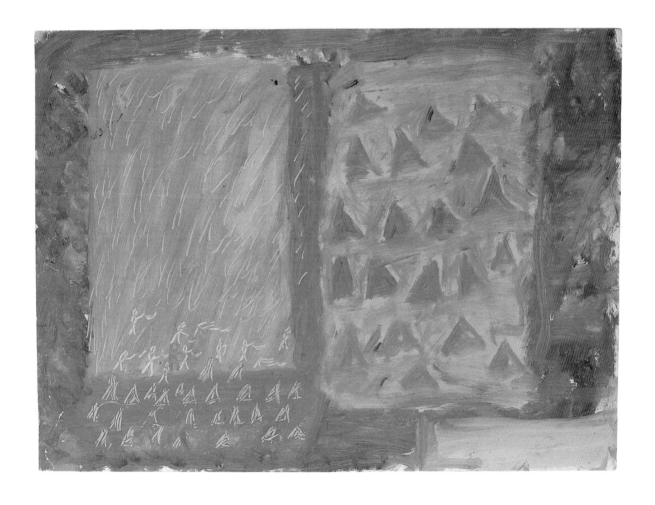

71
James Dixon
Marquetry box
1911
wood
Private collecion

James Dixon
Ship in a glass case
ca. 1953
wood, glass, string, paint
case 43 x 40 x 35 cm
Private collection

Alfred Wallis

Sources

Ben Nicholson to Jim Ede, 29 August 1942
Letter from Kettle's Yard Archive

Wallis got too old to look after himself alone about a year ago and went off to the Madron Institute, near Penzance – we (Adrian, Barbara & me) were worried about this at first but could find no other solution owing to war conditions & in the end he settled in v. well & with an extremely nice Welsh 'Master' and charming Matron whom I know looked after him well – & after a month or two his ptgs were admired greatly by them, & the nurses & the cooks & the inmates! But he has had to go to bed about 3 weeks ago & I went over shortly after & he seemed to me through with his life. Up till quite a short time ago he'd been drawing and ptg but he seems so old now that there is not much of himself left. He asked after you once some time ago & I said you were in America which seemed to comfort him as otherwise I think he thought that you had forgotten about him or his work. No, I don't think a good Wallis is unrepresentational it is simply REAL? For the same reason I don't think a good non-figurative Picasso is photographic – it simply is an immensely real experience and since our visual experience has come from what we've seen it is necessarily representational in the sense that it's been experienced visually – people confuse representationalism with reality

Christopher Wood to Winifred Nicholson, 31 October 1928
Letter from the Tate Gallery Archive (TGA 8618)

What did Jim think of Admiral Wallis – I often see, took him some baccy & a few papers last evening he showed me those lovely boats Ben sent him, I think he appreciated them as he had noticed much the same construction as his own pictures, He said when he came to my house that "they looked as well as anything draw em off ... more and more influence de Wallis not a bad master though".

Adrian Stokes, *Colour and Form*, London 1937, pp. 63–66

A better painter will note the intercourse between water and stone, the carving of stone by water: he will see the stone as a concretion of the liquid form. Then the rock or causeway mounts from the water as from its proper floor. Movement, restlessness, the endless to-and-fro of water lays the foundation for the statuary of substance just as does plastic exuberance for carving conception: and it is with this fantasy strongly in mind that I have written in *Stones of Rimini* of Venice, of the limestone Mediterranean countries, of their seas and of the basis of the art-forms perennial there.

A better painter still will probably eschew altogether a subject of sea and rocks because the imagined progression is too far-fetched for concrete realization. But he may well use his feeling for this progression or concretion in the representing of boats upon the water. Thus, the old fisherman of St. Ives, Alfred Wallis, inspirer of Christopher Wood in his last period, often paints his seas with earth colours, white and black, colours which, if gathered up, will equal in hue or in tone or by some sort of affinity, the colour of his boats. But then he has been a fisherman all his life, accustomed to conceive the sea in relation to what lies beneath it, sand or rock and the living forms of fish. For him the colour of the sea is less determined by its glassy surface that reflects the sky. The surface of his sea, seen best on grey days, is the showing also of what lies under it, and boats are further showing compact for carrying men, an elaboration of the sea-shell, a solid darkness from the depth, the final fruit of an organic progression.

Wallis in one picture has painted a red-brown boat upon a dirty white-brown sea with white icebergs at the back of the picture. The subject is a voyage to Labrador. A warm coloration is used successfully to convey the dead-cold sea of melted ice-slush. Were the hue of the sea without adjacence to the darker colour of the boat, this disintegration of ice-slush would not have been suggested. One's sense of a coloured area added up and 'going into' another, allows the impression of augmentation and of disintegration. Boat and sea are in reality bound by interaction. Without any direct suggestion of weight or movement or buoyancy, this general, as well as a particular, relationship is thus fixed. At the same time the significance of the slightest difference in colour and tone is dramatized. Great meaning of coldness belongs to the dirty white tinges in the sea, and equally to the slight reddening of the boat, haven of comparative warmth upon the waste.

Wallis' brown boat upon the slush-brown icy sea is a form of which I shall never tire because its fixture there palpitates anew and anew. Two opposite references, two worlds of feeling are merged in this earth-coloured sea to which the boat is joined, not as one form posed in relation to another, but as a form with roots in another, as it were, from which it grows and whose opposite nature it displays under the dramatic guise of rooted affinity. Within so narrow a range, the power of colour in the portrayal of difference by means of a deeper identification is used to the utmost. So often in pictures, colours do not fecundate each other but reduce each other's brightness. It must always be a characteristic of art that much should be obtained with simplified means. No colour is good colour of which this is untrue.

Painters more sophisticated than Wallis, also possessing carving vision, will accomplish identity in difference and difference in identity by more complicated adjustment. A poetic relationship between different forms, different textures and distances, may be suggested by a substitution in colour, as when Matisse takes the major blue out of his sky and puts it into the blue of curtains before a window. (I shall not attempt for the moment to discuss how this act of substitution is suggested in the picture.) A certain interchange or metamorphosis of character is effected, one aesthetically pleasing because it is a poetic re-statement of that unity-cum-difference of carving conception. Both curtain and sky are enhanced in their intercourse. (But this would not be the case if from the hint of substitution our sense of the normal colour of things were outraged.)

Ben Nicholson, 'Alfred Wallis', *Horizon*, 7, no. 37, 1943, pp. 50–54

The real story about Wallis is written in his work, but I will try to recall some of the facts about him and some of his remarks. He was born in 1855 and lived to be eighty-seven. He began painting when he was over seventy, as he said "for company" because his wife had died and he did not care for the rest of the company in St. Ives, where he lived for the last fifty years of his life.

In August, 1928, I went over for the day to St. Ives with Kit Wood: this was an exciting day, for not only was it the first time I saw St. Ives, but on the way back from Porthmeor Beach we passed an open door in Back Road West and through it saw some paintings of ships and houses on odd pieces of paper and cardboard nailed up all over the wall, with particularly large nails through the smallest ones. We knocked on the door and inside found Wallis, and the paintings we got from him then were the first he made. In a recent number of *Horizon* there was a description of how Klee brought the warp and woof of a canvas to life; in much the same way Wallis did this for an old piece of cardboard: he would cut out the top and bottom of an old cardboard box, and sometimes the four sides, into irregular shapes, using each shape as the key to the movement in a painting, and using the colour and texture of the board as the key to its colour and texture. When the painting was completed, what remained of the original board, a brown, a grey, a white or a green board, sometimes in the sky, sometimes in the sea, or perhaps in a field or a lighthouse, would be as deeply experienced as the remainder of the painting. He used very few colours, and one associates with him some lovely dark browns, shiny blacks, fierce greys, strange whites and a particularly pungent Cornish green.

Since his approach was so childlike one might have supposed that his severe selection of a few colours was purely unconscious, but I remember one day he was complaining that he was short of some colours, and when I asked him which, he said he needed rock-colour and sand-colour, and I got these for him in the yacht-paint he was using. Kit Wood remarked that it might easily spoil his work to give him new colours when so much of its point depended on the use of a few, but it seemed to me that since he had asked for them he must be ready to deal with them. Next day he made a new painting using, of course, rock-colour for anything but rock and sand-colour for anything but sand, and keeping to his usual small number of colours; and as I went out, having admired the colour of the painting (we had, of course, not spoken to him about the number of colours he used), he said: "You don't want to use too many colours." All the same, he was still sufficiently childlike to make the "s" at the end of his signature whichever way round he felt inclined to, and, when I showed him a reproduction of one of his paintings in a book, to push it away and remark: "I've got one like that at home."

The neighbourhood where he lived regarded him as an eccentric curiosity and his paintings as nothing at all. He was a very fierce and lonely little man and I think it obviously meant a very great deal to him (almost everything, in fact, as it does to any artist) to have the idea in his painting appreciated and taken seriously; and although he appeared to ignore the money when he sold a painting, he was really very proud of selling his work, and the grocer to whom he used to take cheques which were posted to him said that he used to come in with them as proud as punch.

When I returned to London I showed his work to many friends, and he soon had a large number of admirers like H.S. Ede, Herbert Read, Adrian Stokes, Geoffrey Grigson, C.S. Reddihough, John Aldridge, Helen Sutherland, Margaret Gardiner, John Summerson, Barbara Hepworth, Winifred Dacre and many others. Ede in particular took a great deal of trouble about him and his work, and several Wallises were usually to be seen hanging in his office at the Tate Gallery. He used to post us parcels of paintings done up in many sheets of old brown paper, criss-crossed and knotted with a thousand pieces of string, and it was always exciting opening these parcels to see what good ones might be inside.

At about that time some of his paintings were shown in London at a '7 and 5' group exhibition at Tooth's Gallery, and later some also at the Wertheim Gallery; more recently I gave one to the New York Museum of Modern Art. These, I think, were the only paintings which have been exhibited, though the first article to be published in *Cahiers d'Art* in 1938, on contemporary art in England, commenced with a reproduction of a particularly fine Wallis and contained an appreciation of his work by Herbert Read.

He was not apparently interested in the paintings of any other painters, although I think the fact that he lived almost next door to the St. Ives Art Gallery, and that artists were working all round where he lived, must have originally set him going. He did occasionally get hold of an old canvas with a portrait on it which someone had thrown away and would start to correct it, i.e. to make it into a Wallis, but he usually left off correcting it about half way through and the result was rather astonishing. He used to refer to other artists as real artists, saying that he was not a real artist.

He enjoyed talking about his paintings, speaking of them not as paintings but as events and experiences. I can remember when looking at one of those paintings of houses into which he put so much affection (and to which he gave such fierce expressions), he said: "Houses – houses – I don't like houses – give me one ship and you can take all the houses in the world!" Another day, after talking about the war, he said: "To think that man has come to this," and, looking at a painting he had made of the Ark on Mount Ararat, he said: "What man requires is more worship in the valleys and on the mountain tops too." On another occasion, after he had stood by his table and talked for a long time about mankind, and the Bible, and about £40 he had kept in a chest and which someone had stolen from him (an event which must have happened long ago but which he always kept referring to as if it had happened yesterday), and after he had told me to mind what company I kept, and explained that he never kept any company "male or female, town or country," as he was then very deaf and there was no possibility of replying, I held up a painting and pointed to a large, fierce-looking fish in it, as big as a fishing boat, near the edge of the sea, and said: "What's this?" He stopped talking, his face lit up with the most charming expression and he shrugged his shoulders. "That", he said, "that's a land-shark" and he went on smiling for a long time after that.

As far as I could see he read only two books: an enormous black Bible and an equally enormous and equally black Life of Christ. The Bible he read every day and continually pointed to it, saying that all that man required to know was written in there. He wrote in a letter in 1935: "I shall only do one in and out if i see any Thing new That strik my atension i Tell you what i am a Biblekeeper it is Red 3 hundreds sixty times a year By me and that is averyons Duity."

One day, on knocking at his door, I could get no answer and discovered from a neighbour that he had been ill and had been taken to Madron Institute. We explored the possibilities of having him removed from there and looked after, but under wartime conditions the difficulties proved too great. He was well cared for by the master and matron of the Institute, who were intelligent and extremely kind, and it was not long before he was telling the nurses to mind what company they kept, or before the inmates, nurses, matron and even the cooks were admirers of the ships he drew and painted, and he was working up to within a fortnight of his death. On one of the last occasions on which I saw him, about a month before he died, as soon as he caught sight of me he got up and came straight towards me, saying: "I've been wanting to see you. I want black and white and green. Enamel. In tins. Sixpence each." As he had recently been using blue I said: "What about blue?" "No," he replied, "I want *black* and *white* and *green*."

Wallis's motive: creating "for company" and his method, using the materials nearest to hand, is the motive and the method of the first creative artist. Certainly his vision is a remarkable thing with an intensity and depth of experience which makes it much more than merely childlike. In a painting of a fishing boat entering a harbour there is a formidable organisation, a rhythm in which the movement of the whole landscape (in which every form and space has been experienced and perfected) and of the small boats leads up to the decisive purpose with which the fishing boat moves and the four men direct it into the harbour: his imagination is surely a lovely thing – it is something which has grown out of the Cornish earth and sea, and which will endure.

Sven Berlin, 'Alfred Wallis', *Horizon*, 7, no. 37, 1943, pp. 41–50

... Alfred Wallis was born at North Corner, Devonport, on 18th August 1855, the son of a master paver; his mother was from the Scilly Isles; she died when he was too young to remember her. The family were extremely poor, and at the age of nine he went to sea on the light schooners and windjammers of that time; later he worked with the St. Ives fishing fleet as one of the crew of the *Two Sisters* and the *Faithful*, boats which made voyages to the North Sea.

The only authentic tale of a 'deep blue' voyage by Wallis is of a trip to Newfoundland, where they loaded a cargo of Newfoundland cod; on the return journey the ship ran into a heavy gale; half the cargo had to be thrown overboard to save the men's lives. This experience made a powerful impression on him; he was reported lost, and the subsequent shock to his wife resulted later in the death of one of his children, who lived, however, a few months. During this time he lived in Penzance.

In after years Wallis set up his business as marine rag and bone merchant in a cellar at No. 4 Bethesda Hill, behind the wharf at St. Ives, buying and selling junk from the fishing boats and the town. The whole community he knew well – was, indeed, part of it – but he was a very retiring quiet man, and later, when the business was gone and his wife dead, most people came to look upon him as a queer and difficult person, which he undoubtedly was. There was something in Wallis's soul that was unresolved, and throughout the gradual development of his life one sees him all the time searching for fulfilment. As is well known, a society will always tend to exterminate the unusual or abnormal individual; often such an individual is the most sensitive part of that society. These things increased Wallis's unhappiness. Some say that even as long as forty-five years ago he was the butt of children's fun: children who are now themselves hardened fishermen and farm labourers …

Wallis married a Mrs. Ward, formerly Susan Agland, from Seaton, near Beer in Devon; she was trained in making lace, was "strong Salvation Army", and twenty-one years his senior. There were seventeen children by her first husband, five of whom were living when she married Wallis, but only two by Wallis himself, both of whom died in infancy. Alfred was looked upon by Susan as another child – to him she was his 'Mother'. He was good to his step-children, though in later years he became estranged from them. With sanctity and respect for the dead they now speak of him as a good living and kindly man; they tell how he behaved to them as though he were their real father when they were young; it must have been a great sadness to him that he was not.

It was not until several years after his wife's death in 1922 that he started to paint: he was then over seventy. The step-children had died or married – he was completely alone.

Among other things his painting was a supreme effort to put himself in the place of the father, the creator, a function of which life had so far managed to deprive him.

In his little cottage in Back Road West he set to work painting not only on the strips of cardboard he used, but also on the windows, the woodwork, the table, bellows and jam-jars. The passion helped him: he was the tool; he worked with humility. The outward 'bible-punching' personality of Wallis that presented itself to some was not real, or at most only the conscious shell of the man who, in the final issue, achieved the act of unselfing. Wallis was as sincere and gentle about his private approach to religion as he was about his painting, but valued it far more highly.

Until just over a year ago one might have seen this cantankerous little man sitting at his door or in his front room hard at work. Occasionally visitors went to see him – it was fun; but the few people who bought his paintings did so because, quite genuinely, they took pity on him or admired his work. The Cornish people looked upon him as queer in mind. The members of the St. Ives Art Society, with their academic distinctions, their hidebound, unprogressive attitude to painting, when they noticed him at all, considered him as quite unimportant, and smiled at his work like condescending giraffes. From his relations he would accept no help; one of them said of him, earnestly though not unkindly: "Alfred Wallis got what he looked for; he looked to be without a friend; he died a hermit."

Wallis was first 'discovered' by Ben Nicholson and Christopher Wood in the summer of 1928. In the work of these famous artists we read clearly the debt they owe him: I refer to the Cornish landscapes of Nicholson and the Breton and Cornish seascapes of Wood. Several artists have benefited pictorially by Wallis's achievement. The admiration extended by this circle, headed by Nicholson and Wood, was an encouragement to Wallis, because they were the only people who believed in his work, though it had little effect in ameliorating his circumstances.

His paintings found their way into many private collections, also the Museum of Modern Art at New York has him represented; he is reproduced or referred to in contemporary art histories and books on art, such as *Art Now* by Herbert Read, *Colour and Form* by Adrian Stokes; but the artist himself benefited in no substantial way from all this – such things as publication and exhibition had no meaning for him; his works sold for not more than a few shillings each, and no increase

in personal security was forthcoming, which was the keystone to his life, as I hope to show.

His pride in standing in his own home counted for much: it stood for the things he most deeply loved – painting, the sea, and the fireside – which were symbols of life and life unending: but soon these were to be taken from him.

He continued to work on among his fleas and filth, eating little (two 2½ d. loaves lasted him a week, and his grocer's bill never came to more than four shillings), doing his own washing and cooking, save for the help given him by Mrs. Peters, next door, who was the one person from whom he would accept assistance. This lasted until the summer of 1941, when he entered the workhouse, saying he was too old and too ill to continue alone any longer. The doctor had been called in to attend him for bronchitis; finding him in such a filthy state, sleeping on an old couch but as far away from the fire as possible because of the voices that came down the chimney, the case was reported. Wallis made no resistance: "I don't care where I go to be looked after!" he said, and when the time came he was dressed up and waiting to be taken away. He took with him only his watch, magnifying glass and his scissors.

While he was in the infirmary an eye was kept on him by some of those who had bought his paintings, which made conditions a little easier. Materials were sent for his work. In fourteen months he was dead. After his death it was discovered that he had left £21 for burial purposes, which the authorities claimed, to cover expenses, but his admirers had already saved him from this common grave. He now lies among the expensive gravestones of respectable citizens and rich artists.

... He painted the past, the sea, because to do so was an affirmation of *life*. In the storms and thunder of his seas, his lonely boats, we are given the whole conflict of his soul resolved into an organised equilibrium and harmony, the means completely and absolutely welded to the content.

His moral attitude had its effect on his work. His colours though conditioned by material means and limited knowledge were at the same time controlled by a puritanical eye, which gave him a great simplicity and faithfulness of observation ... It was nearly always his practice to paint the sea grey or white, pointing out that if you took a glass of sea-water and held it to the light it was not green or purple or blue but *colourless*. He was *literal*; this word characterizes the man's worth right through.

H.S. Ede, 'Two Painters in Cornwall: Alfred Wallis (1855–1942) and Christopher Wood (1901–1930)', *World Review*, March 1945

Alfred Wallis and Christopher Wood met in Cornwall in 1928; Wallis was then 73 and Wood was 27. Wallis had been to sea since he was nine, had worked with the St. Ives fishing fleet, had sailed in the North Sea, and finally had come to port as a dockyard rag-and-bone man; and at the age of 70 had started to paint. Wood was a public school boy, had travelled much in the world, and had been painting for seven or eight years. It was Christopher Wood who was startled by the meeting....

He wrote to a friend: "I am more and more inluenced by Alfred Wallis – not a bad master though: he and Picasso both mix their colours on box-lids! I see him each day for a second – he is bright and cheery. I'm not surprised that no one likes Wallis's painting: no one liked van Gogh's for a long time, did they?" On the other hand, when someone sent Wallis a number of photographs of Christopher Wood's paintings, he returned them with pictures on the back. he had seen them only as good bits of paper on which to paint....

Wallis was an innocent painter, with a living rather than an intellectual experience, a power of direct perception, using his ship's paint and scraps of cardboard on which he worked to achieve that "significant form" of which Mr Clive Bell once spoke. Each painting was to him a re-living, a re-presenting, achieved unconsciously in regard to the art of painting, but vividly conscious in its factual awareness.

Above: Alfred Wallis' Marine Store, The Wharf early 1900's. Tate Gallery Archive
Below: Winifred and Andrew Nicholson with a model boat made by Alfred Wallis, ca. 1932. Tate Gallery Archive

ALFRED WALLIS' MARINE STORE THE WHARF EARLY 1900'S

Christopher Wood, with all his liveliness, had also the intellectual experience, the consciousness of being a painter in a traditional sense … Both painters, from so different a background, get a shock of joy out of the reality of what they see. It comes in upon them with a deep intensity, and absorbs their whole nature; they are the thing they are seeing; then through that strange miracle which is art they express themselves on paper or on canvas. The result, though it has little reference to actual appearances, does directly symbolize the most significant realities of the thing represented. I find written on an odd piece of paper: "An artist is one who sees the universality of the common incidents of life in an individual manner." I don't know who wrote this, but it applies quite clearly both to Alfred Wallis and to Christopher Wood.…

I remember a painting of a street in St. Ives by Alfred Wallis – endless windows and a maze of roof-tops. It would be difficult to explain the process which has found so varied an assembly of lines in these many-directioned roofs – a startling dexterity of dark roof-tops like the wings of birds in flights – or made of the hundred windows a pattern in no way stereotyped. They are placed with so subtle a judgement, probably quite unconscious as far as intellectual intention is concerned, that they can be quite simply accepted as a whole, and live naturally in their pictorial form. A detailed and factual analysis would lead into a quagmire: skyscrapers of, I think, fourteen storeys in a fishing village where few houses have more than three floors, yet against every rule of conventional perspective they rightly suggest their purpose.…

He has the power to convey the exciting continuity of actual development; the sea-feeling, the ship-feeling, the land in the distance, the pitching and tossing and the passing of lighthouses and other ships, the smell of ropes and vastness of sky, the open sea and the shelter of harbour. A good painting holds potentially these other moments to the one depicted – what I would call the universal aspect, as opposed to the local one – and Wallis achieves this. His painting is felt, as only great and simple painting is.…

… With Wallis design comes, with its subtly variant lines and spaces, not through experience in the art of drawing or painting, but from closeness, almost an identification with the thing he is drawing. I remember another painting expressive of this. It is of a high, many-arched bridge and several boats. There is such a tossing and activity of little boats, as opposed to the unshakeableness of the great bridge, and withal a sure filling of the page. To each arch of the bridge, following from one to another, there is a change of shape, yet each is entirely part of the same bridge. The fundamental character of things is never for a moment lost sight of, yet nothing is ever fixed into the frigid limitation of a particular moment. It is, I think, in this direction that art lives, and Alfred Wallis was here tremendously alive. He is not local, though always topical, and in this again Christopher Wood has much the same outlook, an outlook which was nurtured and illumined by his meeting with Wallis.

David Sylvester, 'The Old Man and the Sea-Piece', *The Sunday Times,* **colour supplement, 31 January 1965**
Opening this week at the Waddington Galleries is an exhibition of paintings and drawings by Alfred Wallis, a Cornish rag-and-bone merchant who started making pictures in his seventies.

"We are the two greatest painters of our time, you in the Egyptian style, I in the modern style." Thus the aged Douanier Rousseau to the young Picasso. The naïve artist, self-taught, self-engrossed, and the avant-garde artist, self-conscious, revolutionary: both sides gained from the relationship. Picasso was directly influenced by Rousseau in certain landscapes and still lives he painted in 1908–09; in return he bought pictures and was generous with admiration of a kind that was needed. The pattern has been repeated, and with good reason. In a period when complicated minds have seen virtue in simplicity and directness, they have felt they had something to learn from the untaught and unteachable. Their attention was welcome to the inspired fools because there was little serious attention to be had from anywhere else.

So fate has had to do its bit in bringing to light some of the naïve painters who have become most widely admired (it's therefore probable that there have been others, equally talented, who will never be heard of). Séraphine Louis, for

example, happened to work in an art critic's household as a maid. Alfred Wallis lived in St Ives because it was a fishing village, but it happened to be a fishing village which attracted painters. In August 1928 two of the outstanding young painters in the country, Ben Nicholson and Christopher Wood, went there for the day....

Wallis was then 73 years old – a little man with a white beard and a bald head – but he had only started painting within the previous two or three years....

His admirers and patrons in his life-time added up to a formidable roll of artists and critics: Nicholson, Wood, Barbara Hepworth, Gabo, Bernard Leach, Adrian Stokes, Herbert Read, H.S. Ede, John Summerson and Geoffrey Grigson were among them.

His work was exhibited around Bond Street and reproduced in *Cahiers d'Art*, the most influential of avant-garde art magazines. And it has come to have a considerable influence on professional painting in this country, and not only through its immediate effect on Nicholson and Christopher Wood. It seems to me that his awkward, lopsided shapes and his range of colours have deeply influenced the work of William Scott, Roger Hilton and Peter Lanyon – leading painters of the next generation – and through them, if not directly, many others.

He, happily, didn't see himself as part of the art scene. Nicholson once showed him a reproduction of one of his paintings in a book: he pushed it away, saying, "I've got one like that at home". If contemporary art had then been the fashionable cult it is now – with naïve painters seen as latter-day saints – the papers and the smart magazines and television would have got to hear of him and he'd have become a celebrity and even, no doubt, a hero to his family. All the same, I don't think that in any circumstances he could have become a Grandpa Moses – not only because of the quality of his talent but because of the sort of man he was....

Albert Rowe, 'The Boy and the Painter: A boyhood reminiscence by Albert Rowe', *Studio International*, 175, no. 907, June 1968, pp. 292–94
In St. Ives, where I was bred, no matter how bitter the family quarrels were, we all believed in the truth of the saying "Blood is thicker than water", and in times of need we acted upon it. So when Alfred Wallis lost his wife and fell upon hard times, Grandfather believed it his duty to help him.

Alfred Wallis and Grandfather had quarrelled bitterly, a long time before – years before I was born in fact – and hadn't exchanged a word since. Neither had any other member of their respective families, for that was the way of it in those days.

Now it was just after his wife's death that I became friends with Alfred and all because I admired one of his paintings. It was the one he'd done just inside his front door and the wooden wall that shut off the parlour from the passage. I remember the incident vividly. I was coming back from a swim – I must have been eight or nine at the time – and as I drew level with Alfred's door, I stopped and looked at the painting. It was of a schooner sailing on a green and white sea. On the horizon was a lighthouse and in the foreground was part of a familiar looking headland. Obviously it was our own St. Ives bay that Alfred had painted. The lighthouse was Godrevy lighthouse, and the headland was part of Porthminster Point. But what fascinated me was the big fish that swam directly below the schooner.

Although it was supposed to be swimming in the water *beneath* the schooner, it was painted as plainly as if it were laid out flat on the surface for all to see. It was a beauty, with a blunt head and a fine curling tail, and it was huge – bigger than the schooner itself in fact.

I liked the painting very much. Although I thought I could paint better boats and sea than that, the fish was splendid, far better than anything I could do. When Alfred came out and stood in his doorway, I told him how much I liked the painting. "Aw, you do, do 'ee?" he said in his deep, gruff voice, surprisingly loud for such a small man. "She was a fine boat, the

'Tribulation', I was cap'n of her, you knaw."

Now Grandfather had told me that Alfred had never been to sea in his life but that because he wasn't exactly right in his head, he always talked as if he had. So I merely nodded and said it looked a fine craft sure enough.
"And the fish", Alfred said, "I suppose you are like all the other fools that pass up and down, you think the fish ruins the picture?"
"No", I said emphatically, "I think it's one of the loveliest fish I've ever seen."
"And you don't think it's too big?"
"No, of course not!"
"And you don't think it ought'n to be there, like all the other blessed fools keep telling me?"
This was too much for me and I burst out: "Well, they are fools right enough then, if they say that – why, it's the best part of the picture, it's – it's a real beauty!"

A smile lit up Alfred's dough-coloured face and he whispered hoarsely: "Ah, you're like me, boy, you're wise." He grinned secretively and patted me on the head; then suddenly, without warning, he shouted: "Dam' fools, all of 'em."

I stepped back in alarm but he smiled as suddenly as he'd shouted and brushing back his grey Crippen-shaped moustache, he said, "I'll tell 'ee somethin' now. See that fish? That fish stands for all the fish that have ever swum – for all the fish that God ever put in the sea; that's why it's so big and powerful."
"Of course", I said
"Come in", he said, "I've got a better picture than that to show 'ee." I followed Alfred in. He stopped at the kitchen table and took off several layers of stained newspaper which served as a tablecloth.
"Look", he said, "Isn't that a real handsome one?"

The whole of the round table-top was covered by a painting. It was another one of St. Ives bay, with Godrevy Lighthouse in the background, but this time the sea was covered by a large fleet of brown-sailed mackerel boats scudding across it. Under the keel of each was a fish, shaped like a dolphin and as long as the boat itself.

"Lovely fish", I said. I didn't think much of the boats for they were the kind I'd drawn when I was much younger and I could do better now; but the fish were fine, so full of life I wouldn't have been surprised if they'd swum right off the table. "I'll tell 'ee somethin' about them fish", Alfred said. He lowered his voice and glanced towards the stairs that led up to the bedroom; "I don't want she to hear. She's up there, you knaw. They think she's dead, but she isn't." Like a flash he sprang across to the bottom of the stairs, his loose grey jersey flapping about his tiny body, and shouted: "I know you're listening, you black-hearted woman."

He came back to the table looking very pleased with himself. "She likes to hark", he chuckled, "but she don't like nobody to knaw she's harkin'. Now about them fish", he went on quietly, "each boat of that fleet – there was over 120 of them when I was a boy and now there's only two or three of them left, and even they have got motors abroad – no boat should have a motor! – each boat of that fleet had a soul, a beautiful soul shaped like a fish; so they fish I'm painted there aren't fish at all – you wouldn't be any good without a soul, would 'ee?"

"No", I said hastily, "nobody would."

"They boats weren't neither, see? That's why I've painted them complete – souls and all – see, boy?"
"Of course I see", I said.
"Now, I've got another handsome picture up in the bedroom; would 'ee like to see that one?"
I hesitated.
Alfred laughed: "I know what's the matter with 'ee; you're afraid of she; but you needn't be. It's alright, I got her locked up

in the cupboard. She's always got her ear to the door harkin', but she can't get out until I let 'er. I only let 'er out once a day and that's quite enough. Come on, boy."

As I followed Alfred up the narrow staircase I comforted myself with the knowledge that there'd be nothing up there – I knew well enough that he was imagining it all; and yet I went up very slowly.

Alfred was waiting for me on the landing. He held open the bedroom door: "There", he said, "Look there boy: on the front of the cupboard. She's inside: and her likeness is outside."

I stared, fascinated, and more than a little frightened. The whole of the front of the cupboard – a cupboard as big as a wardrobe – was covered with a life-sized painting of a woman. She was dressed in black from head to foot – black buttoned-up boots, black stockings, heavy long black skirt, tight black blouse fastened at the throat with a big yellow brooch, black beads wound tightly round her throat. Her face was grey, long and rectangular, her nose hooked, her eyes big and wide open, with protuberant, jet-black eyeballs. Her hair, black and glistening, was piled high in a triple bun on top of her head.

I stared. Although the figure was crudely done, it had a quite astonishing force and life about it; and the eyes, I became convinced, began to look directly at me.

I half-turned, but Alfred said sharply: "No, don't go. Come inside, it's only a painting: and she can't get out, the black-hearted woman. See the halter around her neck?"
I stepped cautiously into the bedroom and nodded: my throat was so dry I felt I couldn't speak.

"Well, that halter is fastened to the gibbet, look, up in the top left hand corner of the picture." He cackled sharply.
"And I'm the hangman, only I haven't put myself in the picture! And see that brooch she's got on?"
I could only nod again.
"That's the one I give 'er. I got it from Andrew Armour up at the old curiosity shop. Like to see it would 'ee?"
I shook my head violently.
Alfred ignored me: "She wanted to be buried in it, but I took it off her before they screwed her down, black-hearted bitch!"
I'd had enough and I managed to say: "I must go now, Alfred, or I'll be late for dinner", and, springing out of the bedroom, I scrambled down to the kitchen.

"Wait till you're like me", Alfred shouted bitterly, wiping the drop that dangled from the end of his nose between his fingers and thumb, "wait till you see more dinner-times than dinners!"

Alan Bowness, 'Introduction', *Tate Gallery Catalogue*, 1968

... He was born at North Corner, Devonport, Plymouth, on 8 August 1855. He often claimed that it was the day of the fall of Sebastopol, a memorable enough event because his father was fighting in the Crimea. His father was a Devon man, a master paver by trade, but his mother was Cornish, from the Scillies. She died when Alfred was very young, and there is no reason to disbelieve Alfred's claim that at the age of nine he went to sea as a cabin boy. He worked in the ships involved in the fishing trade with Newfoundland, either fishing on the Grand Banks, or importing fish from St. John's, sometimes carrying it to Italy. His father had moved to Penzance, and Alfred seems to have sailed from there or from Newlyn.

In about 1875 Wallis married Susan Ward, a woman his senior by 21 years and the mother of his best friend. He thus acquired a family of five step-children, aged from three to nineteen, and a home at 2 New Street, Penzance. Susan bore him two daughters, who died in infancy. After a year or two Wallis gave up deep sea fishing, and became an inshore fisherman, working on Mount's Bay Luggers, and following the pilchard, herring and mackerel seasons. This involved him in voyages

up the east and west coasts of England.

In 1890, aged 35, he gave up fishing, and moved across the Penwith peninsula to St. Ives, to set himself up as a marine scrap merchant....

The business prospered, so that in 1912 he was able to retire with adequate savings and buy his own house at 3 Back Road West. He was then only fifty six, but Susan was seventy seven; in any case the St. Ives fishing industry was declining rapidly, partly because the rich shoals of pilchards had disappeared.

After his retirement Wallis did odd jobs – helping an antique dealer, some labouring during the war, selling ice cream to the children on Saturdays and holidays. Susan was a forceful and likeable woman, a great Salvationist, and she and her children dominated Wallis's life. She died on 7 June 1922, in conditions of some squalor and poverty because, it seems, all the couple's savings had been given to one of Susan's sons who had found himself in business difficulties. Wallis himself may not have been a party to this, and he resented it and brooded on it long after his wife's death: it is the root of the family bad feeling that gave rise to such malicious gossip as that he never went to sea, which is certainly untrue....

Wallis began to paint after his wife's death – "for company", as he said – and painting quickly became his all-absorbing passion. The roots of the obsession in fact go back even further – his step-grandson, Jacob Ward, told Dr. Slack: "he started to paint when he had the marine stores ... grandma used to laugh at him ...". But why did a man of Wallis's background begin to paint at all? Here the answer can only be because he lived in St Ives, where painting pictures has for long been a normal and commonplace activity....

Of course as he painted from memory, and as he was an artist, the images became blurred, and more powerful and meaningful at different levels than a straight forward description could be....

Inevitably Wallis turns to the same ship, or the same place, again and again, but he remembers it differently, and so the picture is different. And though he is thought of primarily as a painter of ships and boats, which isn't surprising given his life history, the variety of his experience is considerable. The range of mood in the country paintings, for example, arrests one immediately from the enchanting blossoming trees in spring; to the much bleaker wintry landscapes which, as Adrian Stokes points out, have an almost Soutine-like quality.

I do not think Wallis could have gone on painting without some encouragement, and he might well have turned to more traditional seaman's hobbies like modelling ships in bottles (which he would have done beautifully) had he not been discovered by Ben Nicholson and Kit Wood....

One final point, about Wallis's place in English painting. He was not an isolated and eccentric figure, but someone who was every bit as necessary to English painters as the Douanier Rousseau was necessary to Picasso and his friends. When art reaches an over-sophisticated stage, someone who can paint out of his experience with an unsullied and intense personal vision becomes of inestimable value. The way in which he used the very simple means at his disposal – yacht paint and odd, irregular scraps of cardboard and wood – is an object lesson to any painter. Wallis shows such easy natural mastery of colour and forms that one can only look with delight and astonishment. It must be enough to make the "real" artists (which Wallis always said he was not) despair.

Peter Davies, 'Notes on the St Ives School. Peter Davies talks to four leading members', *Art Monthly*, 48, July–August 1981
Wilhelmina Barns-Graham: I was fortunate to know about Wallis in 1940 about a month after my arrival because Adrian Stokes had a superb collection of Wallis. Adrian's wife Margaret was a friend of mine at the Edinburgh College of Art. I used

to visit Wallis's cottage and I remember Gabo asking me to take Miriam Gabo's two sons there to visit Wallis with the intention of buying his work, which could be bought for very little. I was a very diffident post-graduate student on a scholarship, and poor, and combined with feelings about getting the work cheaply I never bought, but the ones I now own were given to me by Ben Nicholson, Sven Berlin and George Buchanan's first wife, Mary. My studio was practically next door to Wallis and I used to see him scuffling to his bin emptying his rubbish or standing in his doorway. A little man, pallid, not unlike others one saw around at that time. Wallis thought the real artists were the ones in the nearby Porthmeor studios, the RAs. Wallis did not open his doors very wide at first, being suspicious, but he relaxed after a little and I remember on one occasion peering in. It seemed grey and dirty, paintings everywhere, even the table top was a painting. Piles against the walls and in the doorway on the right-hand side panel were paintings one after another, if I remember correctly, no interval between them from ceiling to floor, greys, blacks and green on cream-painted panels. Children sometimes teased him. The locals thought him odd and thought nothing of his work. A cartload was destroyed, burnt at Zennor, by the big stone there, we were told. I worked during the war with locals who knew him well and were surprised by my interest in him. One woman whose cottage I used to visit in those days had a book inscribed 'From Ben to Alfred'. It had photographs of Wallis-type boats in it. I remember the day he went to the workhouse where later he died. I missed him....

Sven Berlin, 'Postscript', *Alfred Wallis: Primitive*, London 1949, p. 121

Alfred Wallis died of senile decay at Madron Institution on August 29, 1942. Within a year of that date Sebastopol had fallen again.

At his own request he was given a Salvation Army funeral – the arrangements for which were made by Adrian Stokes – and was buried in St Ives Cemetery. The Institute had given no notification of Wallis' death until the previous day. Mr Stokes' diplomatic and vigilant help procured a grave for him at the last moment when the coffin had already arrived, saving him from the pauper's corner. He now lies among respectable citizens and rich artists of St Ives.

After it was all over Mrs Peters came forward with £20 which Wallis had saved and given her to cover funeral expenses. This was claimed by the authorities.

The funeral was a queer little ceremony. Beforehand, Major Holley of the Salvation Army had been primed as to Alfred Wallis' gifts, and his fond speech in the enforced intimacy of the stone chapel – well meant, but comprehending little of the poignancy of the occasion – gave the situation a slightly ludicrous twist: words emulating the powers of the deceased, words addressed to the relatives who felt and understood little, and to a handful of artists from the outer world, who, each in their different ways, saw the thing as it was: Gabo with the look of a man who feels seriously about death; Manning-Sanders with his roving eye, slightly cynical; with her own particular fantasy; Bernard Leach, tall and grave; and Barbara Hepworth, pale and impersonal.

It is a strange place at any time: stark white crosses on a sloping hillside of the northern shore, flanked by Clodgy Point and the moors to westward, and the "Island" and grey roofs of the fishermen's town to the east – between these points the wide unbroken sweep of the Atlantic Ocean.

Cornish rain was drifting down, mingled with the smell of the gasworks and the sea by which Wallis had lived for so long, wetting the newly dug earth, the bare-headed onlookers, the grass mounds, the ornate marble – all equally impersonally.

Against this sombre background the flowers seemed unearthly.

James Dixon
Sources

Previous pages
Top left: Painter Anthony Meehan in the late
James Dixon's house, which is now a gallery
Bottom left: Winter storm, Tory Island
Top right: English painter Derek Hill
Bottom right: The ancient well at St Colmcille's
monastery in West Town, Tory Island
Photographs by Martine Frank

Colm Toíbín, 'The Island that Wouldn't Go to Sleep', *Magill Magazine,* **January 1984, pp. 48–54**

The German's face has turned green. Each wave rises higher than the boat and as it subsides salt water hits the deck with the force of a bucket of water thrown in your face. For ten miles from Tory Island to the mainland the crew of the fishing boat look on stoically as the passengers suffer and are drenched. There is no shelter on the open sea, just as there is no shelter on Tory Island where not even a tree grows. And it is difficult on this journey for the passengers who are being tortured by the elements not to consider what it would be like in the winter. The winter hasn't started yet.

It was not thus several days previously for the voyage out. The voyage out was glorious; the sky was blue, the sea calm. There were even two boats ready and willing to go to the island, although both had to be loaded first. A tractor and trailer reversed down the pier. The trailer was full with bags of turf and each bag had to be put on the boat.

There is no fuel on Tory Island. Nothing grows on Tory Island. Everything, the turf, the bricks to build the new chalets, the pipes for the new water scheme, the pump for the new water scheme, the food, milk, cans of beer, bottles of gas, everything comes ten miles from the mainland.

For weeks on end and sometimes for months on end the island is completely cut off. In 1974 it was cut off for seven weeks. The islanders hoped they would never have to live through a winter like that again. There is always a feeling that most of the islanders will never face another winter. They watch each other carefully to see who will leave first. As we go to press the Christmas post has not yet arrived on Tory Island.

It is not the lack of supplies, although that too is important. The worst thing during the winter is the feeling that you are left out there ten miles off the coast of Donegal, that no one cares, that no one might ever come again. There is nowhere to shelter; every time you open your front door you are hit in the face by the wind and the rain. Even a walk down the road, or what they call a road on Tory Island, is hard work.

However, the winter hadn't come yet and it was thus hard to imagine the winter. This was the smoothest crossing you could ever have. This was like the Mediterranean on a hot summer afternoon: the clear sea, the sharp blue sky, the burning sun. Except for the wind. The wind made it clear that you were in Donegal. It wasn't harsh, or cold, or threatening in any way. But it was the sort of wind that could change and make its presence felt.

They were on the pier waiting for the boat. Some children, but mainly men waiting to load the turf onto the pier. There are two piers, one here in the West Village and the other beyond in the East Village. But there is no harbour. Tory Island needs a harbour.

The West Town is the bigger one. The church, the priest's house, the school, the post office, the new knitting factory, the shops, the hall are all in the West Town. There is one street going towards the lighthouse. All the houses are huddled together in this street. Even though it's the summer some of the houses are boarded up.

It was Saturday night on Tory Island. Inside the shops in the West Town there were men sitting up at the counter looking out towards the street and making the odd remark to each other. The light was fading and the sky had clouded over. The shop was so near to the sea that you could hear the sound of the waves hitting the pier. The men were drinking cans of Tennents Lager: the cans had the brand name printed on one side and on the other side was depicted a woman who was scantily clad and in a seductive pose. Tennents, coupled with whisky and poitín, is the staple diet of the drinkers on Tory Island. This reporter saw no poitín and none passed his lips, but he was told by an inhabitant that a consignment of poitín had recently been found on the island fifty years after it was stashed away.

In the tiny hall of the shop there was music playing out of a huge cassette player. Ballads, ceilí music, but loud, really loud. Outside in the street loads of kids were having a great time throwing sticky burrs at each other and then running away.

Three girls came into the shop and sat down. This created a bit of a stir.

A bloke with an accordion appeared accompanied by another bloke with another accordion. Then a fellow with a guitar joined them. They were almost blocking the entrance to the shop as they began to play. A bodhran player arrived shortly afterwards.

Then there was a huge commotion out in the street. Hens scattered squawking in all directions. Everybody who was standing outside in the street stood aside as a tractor and trailer bearing islanders from the East Town, which lacked a shop of its own, came down the hill from the church at breakneck speed and stopped, in true Hollywood fashion, with a sudden jerk.

It was clear there was going to be a space problem in the shop so due to this and the fact that the night was fine benches were put on the street for the musicians to sit on and everybody stood around with cans of Tennents in their hands having the time of their lives. There was no thought of the winter in anyone's head. No thought that in early January not even helicopters would be able to brave the storm.

Derek Hill, 'Introduction', *Dawson Gallery Catalogue*, 1967

James Dixon says he was born on Tory Island on June 2, 1887. His father came from Meenlaragh on the mainland of Donegal and his mother was a Miss Diver from the Island. He had three sisters and three brothers in the family – one brother and one sister are now resident in America. Apart from an occasional visit to the "country" as the islanders call the mainland, and one short period in the west of Ireland as instructor on a fishing course, Jimmy tells me he has never left the island. His life has been devoted to fishing and the usual cultivation of land and only at odd times did he paint a migrating bird he had noticed, or a flower from his sister Grace's garden. This was until some six or seven years ago when he saw me painting a large landscape of West End village from the headland opposite to the harbour and the celtic round tower. A crowd gathered round me after Mass, and Jimmy said "I think I could do better". I encouraged him at once and promised to send him paints, size and paper (he prefers paper to canvas), but he refused brushes, saying he could make his own out of donkey hair. This last factor seems important for his work as it helps, I think, to give the painterly quality one finds. They are all painter's pictures and not merely picture making which comprises so much of the output in the art world today, whether in abstract or figurative painting. It's a hard definition to explain, but it is largely concerned with the texture of

paint and the brushwork, as well as an unusual vision of the natural phenomena around.

Almost all the landscapes of Donegal one sees in exhibitions or on sale on hotel walls represent the extreme 'picture making'. Flashy, gaudy colouring, quite unlike the soft western tones one finds in Donegal, and equally flashy, dextrous brushwork to depict the sudden glimpses of sun on a white-washed cottage wall or the blue shadow-dappled mountain, usually transformed into a completely unnatural solid wall of hot purple. Possibly alright for a tourist to take home, as a very approximate rendering of where he has spent his holiday, but nothing to do with the real business of painting. As unlike as silver-papered process cheese is to a genuine Stilton. Stilton is the 'real stuff' and so is Jimmy's painting.

The scenes he chooses to paint on the island are the very opposite of picturesque; they are often harsh, rough and ready made, but they are deeply concerned with the life that an islander lives. Muldoons caught in the nets, fishing boats at anchor, the great East End cliffs of Tormore – little to offer to people who want a pretty picture. The clumsiness may be called child-like or primitive, but it is true and intimately related to the place where the pictures have been painted. John Berger, the critic, referred to Tory Island as being like a boat adrift with wreck survivors, but with no hope of ever reaching the mainland.

Jimmy Dixon's paintings describe just such a situation. His colouring and brush work is the exact opposite of the pretty landscape picture makers. His are painted quickly and instinctively and often seem to be painted in the face of a gale that seldom stops on the island; unrestful and turbulent, not equally successful by any means, but always 'himself' and honest.

Jimmy is not the only painter on Tory, but he is the most prolific, and when a new bundle arrives for me to sort over for him, they are often still wet and stuck together and I imagine them thrown into the sea and washed ashore after a storm. They are all part of it – part of an element or natural untaught force. It must be almost literally true to say Jimmy has never seen any other paintings beyond an occasional glimpse at the few that some visitors to the island may have done. His are as untutored as any one could find in Europe today – simple and isolated as the island they come from. Within fifty years his island may well be abandoned by the inhabitants and these pictures could be an invaluable record showing the last years of an outpost of the civilised world. A record of struggle and hardiness carried out with primitive tools and with a haste or urgency to get the work done before it is too late; before the last boat has finally left for the "country".

George Melly, 'James Dixon', in *A Tribe of One: Great Naïve Painters of the British Isles*, Yeovil 1981, pp. 61–69
I have in front of me a painting on paper by James Dixon, a gift from the artist Derek Hill who discovered and encouraged this extraordinary naïve.

In the right-hand corner is, as was usual with Dixon, a small rectangle of the paper left uncovered, with its title and date and the artist's signature written in pencil. It reads 'Grey Lag Geese Resting on the West End Lake Tory Island. By James Dixon. 4.5. 1969'. It is comparatively rare for painters, unless they are as prolific as Picasso, to note the day and the month.

This precision in no way extends to the picture itself. It is painted with wild expressionist abandon, the brush strokes sweeping rhythmically around the central image, paint splashed on here and there like spray driven by the wind, much of the drawing realised by scratching the end of the brush or some other sharp point into the wet paint to produce a white line.

Of the painters in this book Dixon and Wallis are closest; Wallis also scratched in the details in this way on occasion; but where Wallis is restrained and contemplative, Dixon is an elemental painter. His work suggests a force of nature, and not a very kindly nature at that....

Most of his work relates to the life around him, on Tory Island, a small, rocky storm-beleaguered place off the coast of

Donegal. Only occasionally did some outside event impress him enough to inspire a picture, and that was usually connected with the sea: *The Sinking of the Titanic* [no. 56], and *Jessy (Gypsy) Moth* [no. 62] are two examples. As a rule though his subjects were the birds and beasts of the island, the fishing and its hazards, 'Muldoons' (herring-whales) caught in the flimsy nets, the great cliffs and the relentless battering of sea and wind.

I have mentioned Wallis several times in connection with Dixon and there are indeed several other parallels: their background as fishermen, their treatment of pictures as events, their lack of finish, their late beginnings, and above all their genius. Furthermore they were both discovered by professional painters. But unlike Wallis, who had begun to work seriously by the time Wood and Nicholson discovered him, Dixon had painted practically nothing before he encountered Hill – only the odd migrating bird or a flower from his sister's garden. What happened was this.

Hill (who lives in Donegal but frequently spends several weeks on the bleak and isolated Tory Island) was painting a large landscape of West End Village from the headland opposite the harbour and the Celtic tower. It was a Sunday and, after mass, a crowd gathered round him. On Tory Island anything counts as an event, and a painter at work was not, in those days, a common spectacle. Hill's pictures, while extremely sensitive, are not difficult to read at a representational level, and I imagine that in general the reaction would have been favourable. Dixon, however, was unimpressed. "I think I could do better" he said. It is very much in Hill's favour that instead of being offended as many a professional might have been, he immediately encouraged the old man and, as he then promised, sent him paints, size and paper (for which he expressed a preference over canvas), but no brushes....

From then on Dixon painted continuously, sending Hill large bundles of pictures which were frequently dispatched before they were dry and in consequence stuck together. Here again there is a parallel with Wallis and his parcels to Nicholson and others. Like Wallis, Dixon showed no sense of self-criticism: masterpieces and less successful pictures were packed together, but even the weakest was a direct expression of feeling.

What is unique, and at first surprising, was the effect of Dixon's work on those around him. As opposed to the mockery or indifference with which his neighbours greeted Wallis, the Tory Islanders not only found nothing odd about Dixon's activities but in some cases were soon to follow his example. Hill maintains that James' brother Johnny, although less prolific, was his equal and that perhaps one James Rogers, who only did five pictures in all, was also as good. Painting joined fishing and meagre agriculture as a local activity. What's more there is now a new generation of painters working on the island in a much tighter, "more Hockneyish" style according to Hill. The tradition continues.

... Having talked at length to Derek Hill I gather that, as far as it is possible today, the island is a true primitive community, a tribe unspoilt by much contact with the outside world. There is no hotel and in consequence few tourists. There is not even a licensed pub. Visits to "the country" as the Islanders call the mainland are rare. Dixon himself for example, apart from the short period as a fishing instructor in the west of Ireland, left Tory Island on few and brief occasions. There is a strong and unique culture centring on music, and a beautiful dance called 'The Waves of Tory'. There is much idiosyncracy. Dixon's sister Grace, of whom he painted a picture *Calling the Cattle Home*, enjoys *The Tatler*, taking a keen if amused interest in the distant social goings on while Dixon himself, somewhat untypically for a citizen of the Irish Republic, was a great admirer of the Queen and Winston Churchill and sent them both portraits. What's more, for all the harshness of the life, there is a fierce devotion to the island; the greatest fear of its inhabitants is of enforced evacuation to the mainland. In consequence, given such isolation and independence, there were no built-in prejudices against the idea of painting; it seemed a perfectly natural activity.

Dorothy Harrison Therman, *Stories from Tory Island*, Dublin 1989, pp. 160–61
Pasty Dan Rogers describes Derek Hill's first meeting with James Dixon
Around 1956–57, I remember well, a gentleman called Derek Hill came out here to Tory Island. He stayed in the village the first couple of years, I believe ... I could hardly say that he has missed a summer on the island since 1956. So I would dare

say that he was on the island roughly two to three years when he was painting, one Sunday morning, down below our church – at the Big Strand, we call it. And immediately after Mass, one of the islanders walked down and was all excited looking at Derek Hill painting this view of Tory, right across the harbour so to say.

And then Derek Hill knew that one of the islanders was looking at what he was doing. So he turned round and said

"Good Morning". And the islander said "Good Morning" as well. And he (Derek Hill) says "What do you think of my painting?" And James Dixon, the islander who we are talking about, was smoking a pipe, pushing down the tobacco. So, "Well", he says, to answer back Derek Hill, "I think I could do it myself."

So that's how the primitive painting and the primitive school of art have started on Tory. So anyway, Derek Hill was amazed over this answer they arranged to meet later on in the evening and Derek Hill walked all the away down from the hut again and went over to James Dixon. And he days, "Look here, if I send you the materials, the brushes and the paints, will you start painting?"

"Well", James Dixon says, "I'm sure I will", he says, "But look here", he says, "send out nothing more than a few tubes of paint to me."

"My God", Derek Hill says, "do you not want brushes and so on?"
"No", he says. "I will manage the brushes", he says. "Because I have horse up in the field and he has a long tail", he says, "and I will make the brushes myself out of the tail", he says.

So he was really meaning every word that he was saying. So James Dixon started day after day lashing away at his paint, getting down to his art work. And every day and every week was passing; and little he thought himself that each and every one of his paintings would speak out a mile for itself – and so they did at the end.

Brian Fallon, '"I could paint better than that" Brian Fallon on the work of James Dixon, the best of the Tory Island Painters', *The Irish Times,* **28 July 1990**
On Monday an exhibition opens in the Glebe Gallery in Donegal (about a dozen miles from Letterkenny, by the way, and near Glenveagh National Park) of the work of James Dixon, the one 'primitive' painter of importance that Ireland has produced. Primitive painters, of course, come ten to an Irish pound nowadays....

Dixon, however, is something else. He was a fisherman by trade and was an old man before he knew that he could paint at all. His discoverer was Derek Hill, the English-born landscapist and portraitist, who for many years has kept a small studio-hut on Tory Island, off Donegal, where he goes periodically to paint. It was while watching him at work that Dixon got his first opportunity of handling a brush. "Mr Hill", he said, "I could paint better than that." Hill replied, "Well, why don't you?" and passed him his brushes and paints.

At that time, Dixon was already an old man, and his work was produced in the last period of his life. Most of his pictures seem to be done on paper, though it is usually good-quality art paper (again, donated by Derek Hill). Since his death, the whole school of Tory Island primitive – Patsy Dan Rodgers and others – has become well known and exhibitions of their works have been frequent. Dixon, however, is by far the best of them, and really stands alone....

Meanwhile, the salerooms are catching up with Dixon. Not long ago, you could pick one of his pictures up for as little as £10 but at the moment they are inching into the thousands.

Above: Derek Hill, *Portrait of James Dixon,* oil on canvas, 74 x 89 cm, The Collection of the Arts Council of Northern Ireland
Below: James, Grace and John Dixon, Tory Island, 1960. *Photograph by David Braddell*

Brian Fallon 'The Primitive of Tory Island. Brian Fallon writes about an exhibition at the Glebe Gallery in Donegal', *The Irish Times,* **29 August 1990**

The Tory Island School of painters has been publicised a good deal over the last decade, and their work has been shown as far afield as Paris. So to mention any one of the group is tantamount to a package deal; all for one, and one for all. Some of them are still living and producing, and they can be wished well but most primitives paint the same kind of picture, though one may be better than the next. James Dixon, whose work has been on show for the past month at the Glebe Gallery in Donegal, is something different....

I have made the comparison with Wallis more than once myself, but on seeing this exhibition I am doubtful as to how far it can be taken. Wallis's pictures are usually small – very small, sometimes – and concentrated and he painted the sea and ships almost exclusively. Dixon's are bigger, looser and freer in style, without the stark, almost apparitional quality of Wallis, and besides sea subjects he painted landscapes of a sort, flower pieces, even figure pictures – though these are generally the weakest.

It is fairly well known by now that Dixon took up painting after seeing Derek Hill at work on one of his regular visits to Tory. He said he could do better himself, so Hill told him to do so and provided him with paints and even good-quality art paper. He also offered him brushes, but Dixon declined these and insisted on using his own. He was already an old man at the time – born in 1897 – but up to the time of his death in 1970, he painted busily and turned out a large volume of work. From the dates in the catalogue, however, it seems that Dixon must have painted occasionally before his encounter with Hill....

How good a painter was he then? It has been fashionable over the last half-century to praise the work of Sunday or primitive artists, just as it has been fashionable to praise child art. The reasons are obvious: Modernism saw the beauty of sheer pattern, and the magical sense of things which unschooled people can sometimes express without 'learning to draw' in the traditional sense. Dixon did not or could not draw in that sense, and in the figure paintings, in particular he is hardly any better than any of the two hundred other primitives. On the other hand, he was a born painter, his handling is remarkably free and expressive, and he could paint the sea as though born to it, as indeed, he was.

Unlike most Sunday artists, he did not go for static, embroidered patterns, nor was he obsessed with niggling details as primitives usually are. He had an inborn sense of placing and balance and his compositions are dynamic and asymmetrical, often based on slashing diagonals. He was, inevitably, hit-and-miss but in a carefully chosen exhibition such as the Glebe Gallery one, his originality comes over with genuine power.

Nor, of course, everybody's painter, or type of painter. I glanced at some of the comments in the visitor's book and found that some were enthusiastic while others had a slightly offended air, as though they had been victims of a practical joke. But I have seen a number of Dixon shows over the last quarter century, and this one merely confirms what I already thought – that he has a special, rocky niche in the hierarchy of Irish painting.

Malise Ruthven, 'The Other Tories Earn their Keep', *The Observer,* **date unknown**

Pirates and rogues, that's what the Tories were when the word came into British politics. Later, the Irish would have told you, the Tories were indolent and irresponsible. Now the world is coming to hear of a remarkable new Tory talent – as the paintings on these pages show. Malise Ruthven tells the story of the island that woke up and learnt to stand squarely on its own two feet.

A narrow shoulder of granite three miles long and half a mile wide with massive cliffs on the windward side, Tory Island has been the terror of sailors for hundreds of years. It stands alone in the Atlantic nine miles off the north-west corner of Ireland, and a local historian has traced a dozen of the treacherous rocks or 'tors' which, according to some authorities,

gave the island its name. Long ago, the inhabitants' reputation for fierceness and piracy brought the island's name into British politics. Still in Co. Donegal, the word has its proper meaning – 'rogue'....

Some 75 families live in two villages about a mile apart on the leeward side. The main village, West End, with post office, church and school, is grouped round the harbour, a few dozen detached cottages linked by a rough paved road crossed with open drains. A forest of electric wires radiate out from the relic of a tenth-century Round Tower – all that remains of the great monastery founded by St Columcille (or Columba) 1,300 years ago. The islanders' main activities are fishing, what they called farming (really, milking the odd cow, or conjuring a harvest from a few rough strips of arable ground), or simply doing nothing. Isolation – they are often storm-bound for weeks by gales – and complete dependence for supplies on the weather, have led to an indolent and stoic fatalism and apathy towards self-improvement....

Unique among primitives, Jimmy's paintings have an expressionist quality, the result of haste or laziness, which contrasts with the meticulousness of most naïve painting – including that of the other Tory painters. Some have immensely long titles describing their subjects which reflect the arbitrary mixture of fact and fancy, of Tory and its people. Jimmy, who died in 1969, was suitably laconic about his work. He was once quoted as saying: "I don't know why I started painting; something for an old man to do, I suppose. There's nothing romantic about little boats fighting with crashing waves and winds. What all this talk about primitive art is, I don't know."

When Jimmy had sold a few pictures, his brother Johnny decided to take up the lucrative pastime. His paintings are much more careful than Jimmy's, in the convention of naïve painting, and lacking his brother's occasional visionary quality. His output was therefore very much smaller. As another Tory painter put it: "Johnny had more control of the brush." Another old man, Jimmy 'Yank' Rogers, who had been in America, also produced some paintings – careful and meticulous like Johnny Dixon's employing an unusual collage technique in which the outlines of some objects such as boats have been cut out of illustrated magazines before pasted on the picture. Finally, Derek Hill encouraged a much younger man, Patsy Dan Rogers, to take up painting. An exhibition was mounted in Belfast bringing the work of the 'Tory Painters' together for the first time.

The islanders remained blandly indifferent to this explosion of talent. The Dixon brothers painted at home in their spare time, unbeknown to the other islanders until collectors and admirers started turning up to visit them. Each worked in isolation. Their sister, Gracie, with whom they lived and who survives them both, says: "One would paint while the other out fishing or minding the cattle, and then they'd change over." When they were painting, "she wouldn't bother herself with them"....

Later, Gracie says, Jimmy's fame earned him grudging respect from the other islanders – because they thought he must be making money. And now Gracie, despite her former indifference, produces the newspaper clippings and catalogues of Jimmy's many exhibitions with pride. She says her brothers had a gift which the other islanders lack – and points out that they were not "true islanders" anyway – their grandparents came from England or Scotland, she thinks.

Derek Hill, 'James Dixon', *Irish Arts Review*, 1993, p. 179
The story of my first meeting with James Dixon has often been told ...

As far as I know his first attempt, after our meeting, produced the remarkable *Harbour Scene* that Bruce Arnold reproduced in his book on Irish painting. Naturally I bought the picture, now part of the Glebe Gallery collection, and from that moment there was no holding him. This must have been in 1956 or 1957.

Tory Island, a rock three miles long and about a quarter of a mile wide, has no trees and sits in the middle of the Atlantic. John Berger once described the inhabitants as people from a wreck rowing desperately for the shore but with no hope of

ever getting there. The island he felt, when he visited it with me, was about to fall over the cliff edge of Europe. Nothing except the fabled Hy Brasil between it and the setting sun.

I don't think when James commented on my picture he meant to criticise my possible technical ability at representational detail. Luke Batterham wrote in a thesis on Dixon "it was just that the studied, restrained pictorialism employed by Hill to represent the island bore little relation to the Irishman's own experience of the place on which he had spent almost his entire life". Most of Dixon's pictures, apart from the few portraits, are related to the island and what goes on during its daily routine. Proportions, perspectives and topographical accuracy have no part in his work. Animals may appear larger than people and a rather disconcerting aerial view may suddenly be added to a normal flat landscape. He uses dark and sombre colours with white flecks applied for waves or gulls. Browns and blues are mixed and they help to make the greys.

Once, to a local newspaper man, he said "You don't get all that much colour here, except the blue and greys of the sky and the glistening of the sea. There is nothing romantic about little boats fighting with crashing waves and winds." The islanders do fight hard for survival and may through the school of painting that followed Jimmy's example, have achieved this. A long struggle against governmental wishes to evacuate the island.

Shipwrecks were often chosen as subjects by Jimmy, the most famous being the sinking of the *HMS Wasp* in 1884 [see no. 61]. The boat had come from Sligo it seems, to collect island rates long overdue and the inhabitants are said to have turned a cursing stone for its demise. Whatever happened, the lighthouse is alleged not to have been functioning that night and the loss of over eighty lives was the result. There are several pictures of the sinking of the *Titanic*, something that had always made a great impression on Jimmy as a boy. His rival, James Rogers, one of the other island painters, depicted the *HMS California* – the ship that is said to have disregarded the *Titanic* and its signals and that, far later, was wrecked on the island when cruising gently out beyond the West Town harbour.

Some people talk of an early Dixon or a late one, but there's really little difference to be seen in technique between the dates when he was at work. The dates he often wrote, with the titles, on the corners of his pictures are not always accurate. He just painted his own feelings towards a subject, and that was that. Apart from the sea pictures and scenes of islanders herding cattle or attending dog races – something I admit I never saw on the island – he painted birds and flowers and a very occasional portrait of them – as he imagined them. Ellen Ward was already in her late nineties and then he painted her posthumously [no. 40]. He also painted the Queen, titled *To the Queen wishing you the Best of Luck*, and Winston Churchill, whom he greatly admired. His picture of the Queen was sent to her and a courtier replied that Her Majesty wished him many years ahead for his good work. Lady Churchill was given the picture of Winston but its whereabouts can only be surmised, alas, after the destruction of Sutherland's magnificent portrait. He also painted myself, as a present, a Union Jack in hand, wearing a suit and a tie – something I'd never do on the island – and beside me a landscape and a flower picture to demonstrate the things I loved. A typical Englishman! Any true likeness to the subject was not achieved.

Credits

Further Reading

Alfred Wallis, exhib. cat. by Alan Bowness, London, Arts Council of Great Britain, 1968

Alfred Wallis, Christopher Wood, Ben Nicholson, exhib. cat. by Charles Harrison and Margaret Gardiner, Stromness, Pier Arts Centre; Aberdeen, Aberdeen Art Gallery; Cambridge, Kettle's Yard; 1987

Bruce Arnold, *A Concise History of Irish Painting*, London 1969

Peter Barnes, *Alfred Wallis and his Family: Fact and Fiction*, St Ives (St Ives Trust Archive Study Centre) 1997

Sven Berlin, 'Alfred Wallis', *Horizon*, 7, no. 37, 1943, pp. 41–50

Sven Berlin, *Alfred Wallis: Primitive*, London 1949, rev. Bristol 1992

H.S. Ede, 'Two Painters in Cornwall: Alfred Wallis (1855–1942) and Christopher Wood (1901–1930)', *World Review*, March 1945

Matthew Gale, *Alfred Wallis*, London (Tate Gallery Publications) 1998

Richard Ingleby, *Christopher Wood: An English Painter*, London (Allison & Busby) 1995

James Dixon, exhib. cat. by Derek Hill, London, Portal Gallery, 1966

James Dixon: A Retrospective Exhibition, exhib. cat., ed William Gallagher, Co. Donegal, Glebe Gallery; Cork, Boole Library, University of Cork; 1990

Grey Gowrie, *Derek Hill: An Appreciation*, London (Quartet Books) 1987

Kettle's Yard and its Artists: An Anthology, Cambridge (Kettle's Yard) 1995

George Melly, *A Tribe of One: Great Naive Painters of the British Isles*, Yeovil 1981; section on Wallis reprinted in *Alfred Wallis: Paintings from St Ives*, Cambridge 1990

Edwin Mullins, *Alfred Wallis: Cornish Primitive Painter*, London 1967

Edwin Mullins, *Alfred Wallis: Cornish Primitive*, London 1994

Ben Nicholson, 'Alfred Wallis', *Horizon*, 7, no. 37, 1943, pp. 50–54; reprinted in Mullins 1967

Albert Rowe, 'The Boy and the Painter', *Studio International*, 175, no. 907, June 1968, pp. 292–94

St Ives, exhib. cat., Tokyo, Setagaya Museum, 1989

St Ives 1939–1964, exhib. cat. by David Brown, London, Tate Gallery, 1985, reprinted 1996

Theo Snoddy, *Dictionary of Irish Artists: 20th Century*, Dublin (Wolfhound Press) 1996

Adrian Stokes, *Colour and Form*, London 1937

Tory Paintings in Irish Houses, exhib. cat. by Derek Hill, Kilkenny, Kilkenny Art Gallery, 1972

Index

References in **bold** are to plate numbers